An Uncommon MISSION

Father Jerome Tupa Paints the California Missions

Opening

December 2, 1999-
March 12, 2000

San Diego Historical Society Museum and
Research Archives, San Diego, California

April 6-
July 30, 2000

Santa Barbara Historical Museum,
Santa Barbara, California

September 12 -
November 19, 2000

Fresno Metropolitan Museum,
Fresno, California

Exhibition Sponsored by

To John and Connie Pellegrene
for all of their support and kindness
—Jerome Tupa

Published in 1999 by Welcome Enterprises, Inc.
588 Broadway, New York, NY 10012
(212) 343-9430 Fax (212) 343-9434

Publisher: Lena Tabori
Project Director: Natasha Tabori Fried
Designer: Jon Glick

The quotations on pages 92, 94, and 95 are taken from conversations
with Laurel Reuter and reproduced with permission from her book:
In Quest of Spirit: The Painting of Jerome Tupa, O.S.B., North Dakota
Museum of Art, 1996.

Printed and bound in China
10 9 8 7 6 5 4 3 2 1

2

Library of Congress Cataloging-in-Publication Data

Witchey, Holly Rarick.
 An uncommon mission : Father Jerome Tupa paints the
California missions / foreword by Cardinal Roger M. Mahoney;
text by Holly Witchey ; photographs by Terry Ruscin.
 p. cm.
Exhibition sponsored by Mervyn's California, opening Dec. 2,
1999-Mar. 12, 2000, San Diego Historical Museum &
Research Archives, Apr. 6-July 30, 2000, Santa Barbara
Historical Museum, Santa Barbara, Calif., Sept. 12-Nov. 19,
2000, Fresno Metropolitan Museum, Fresno, Calif.
 ISBN 0-941807-34-7
 1. Tupa, Jerome, 1941- Exhibitions. 2. Missions,
Spanish-California--History. I. Tupa, Jerome, 1941- .
II. Mervyn's California (Firm) III. San Diego Historical
Museum & Research Archives. IV. Santa Barbara Historical
Museum. V. Fresno Metropolitan Museum of Art, History,
and Science. VI. Title. VII. Title: Father Jerome Tupa paints
the California missions.
ND237.T8427A4 2000
759.13--dc21
 99-36742
 CIP

AN UNCOMMON MISSION

FATHER JEROME TUPA PAINTS THE CALIFORNIA MISSIONS

FOREWORD BY CARDINAL ROGER M. MAHONEY
TEXT BY HOLLY WITCHEY
PHOTOGRAPHS BY TERRY RUSCIN

WELCOME
NEW YORK & SAN FRANCISCO

THE MISSIONS OF
CALIFORNIA

San Francisco Solano *(est. 1823)*

San Rafael Arcángel *(est. 1817)*

SAN FRANCISCO

San Francisco de Asís *(est. 1776)*

San José *(est. 1797)*

Santa Clara de Asís *(est. 1777)*

SANTA CRUZ

Santa Cruz *(est. 1791)*

San Juan Bautista *(est. 1797)*

CARMEL

San Carlos Borromeo de Carmelo *(est. 1770)*

Nuestra Señora de la Soledad *(est. 1791)*

San Antonio de Padua *(est. 1771)*

San Miguel Arcángel *(est. 1797)*

San Luis Obispo de Toloso *(est. 1772)*

SAN LUIS OBISPO

La Purísima Concepción *(est. 1787)*

Santa Inés *(est. 1804)*

Santa Bárbara *(est. 1786)*

SANTA BARBARA

Santa Buenaventura *(est. 1782)*

San Fernando Rey de España *(est. 1797)*

LOS ANGELES

San Gabriel Arcángel *(est. 1771)*

San Juan Capistrano *(est. 1776)*

Pacific Ocean

San Luis Rey de Francia *(est. 1798)*

San Diego Alcalá *(est. 1769)*

SAN DIEGO

FOREWORD

BY CARDINAL ROGER M. MAHONY,
ARCHBISHOP OF LOS ANGELES

In painting the twenty-one California missions, Father Jerome Tupa has created more than a simple historic record. His mission paintings explode with life, movement, color, and emotion. Father Tupa has recorded the physical details of the missions, and he has also given them a voice that calls out to us, reaffirming the life of the spirit.

The earliest of the California missions—San Diego de Alcalá—dates from 1769. Within the following forty-six years, twenty additional missions were built. In addition to carrying on the work of the Church throughout coastal California, the missions became educational, artistic, and cultural centers for all who wished to use them.

But the story of the missions goes forward in time as well as back. Today, each of the missions is a vital part of California's history and character. Whether we visit the missions to enjoy the gardens, the architecture, or the art, they welcome us. Whether we seek to reconnect with the past or to find peace and strength for the future, the missions give something to each of us.

In the same way, the ongoing construction of the Cathedral of Our Lady of the Angels in downtown Los Angeles unites California's past, present, and future. The new Cathedral—in the mission tradition—will serve as an inspiration for all people for centuries to come.

The Cathedral's design captures, but does not imitate, the spirit of the California Spanish style. It will create a sacred space to uplift heart, mind, and soul, and like the twenty-one missions portrayed so beautifully by Father Tupa, our newest Mission will speak to us across the years.

We thank Father Jerome Tupa for sharing with us the joy, the vision, and the voice of this, his most Uncommon Mission.

INTRODUCTION

BY HOLLY R. WITCHEY

Father Jerome Tupa is a painter, a professor of French, a Benedictine monk, and an ordained priest. Yet in the summer of 1997, he set off with a commission from Mervyn's California to draw and paint each of California's twenty-one missions. Why would such a man take on such a task? Father Tupa had a vision. He wanted, through his art, to give a voice to each of California's missions.

Father Tupa is not the first to draw, paint, etch, or photograph all of California's missions. Over the past two hundred years, numerous artists have felt compelled to record their particular views of California's historic links to Catholic Spain.

Some artists have created images for travel guides or histories of the great missions. Some artists, like Chesley Bonestell and Edward Borein, were obviously struck by the ruined grandeur of the past, and tried either to recreate a lost time or to capture the archaeological romance of the missions. A few artists, mostly Californians, like France Carpentier, created and gathered images of these structures in order to promote the history of their state.

Among all the others, Father Tupa's vision is unique. He does not seek to promote California. He does not try to illustrate or recreate the missions. Instead the twenty-one oils and thirty-nine watercolors in his series offer to us the twenty-one missions

as they are interpreted by a relevant, contemporary artist.

THE CALIFORNIA MISSIONS: REALITY AND FANTASY

Each of us is different from other people, yet we all seek to understand things we have in common with the rest of the world. Perhaps that is why the California missions exert such power. The missions are, in their own way, icons. The twenty-one structures that stretch from San Diego to Sonoma form a chain that links disparate towns geographically, spiritually, and socially. California's missions are the focus of pilgrimages, both cultural and spiritual; they are, in some cases, a source of civic pride, in others a case of civic forgetfulness. The missions and their original occupants are both romanticized and demonized. What is the correct perspective? What is reality? What is fantasy?

Every person who makes a pilgrimage to one or more of California's missions views them through a lens created by his or her own infinitely diverse life experience. For some, the missions reflect attitudes about the discovery and mapping of California. For others, the missions symbolize the hardships of settling in a new land. Perhaps we visit the missions in search of a better understanding of the Franciscan missionaries and the Native Americans they sought to convert. Perhaps

7

we look for information about the religious and social history of California, Catholicism, and anti-Catholicism. Perhaps we seek to understand the eighteenth-and nineteenth-century relationship between New Spain and the emerging United States. All of these ideas have their place in mission history.

Jerome Tupa, however, brings us something old and something new. The lens through which he views these buildings is complex and rich, in depth and breadth. He brings the historical understanding that the California missions are but a blip near the end of the long timeline of written history. The missions came into being at a time when Europe and America were involved in the American War of Independence, the French Revolution, and the reign of Napoleon in France. They share a time in history with Soufflot's Panthéon, Jefferson's Monticello, and Nash's Royal Pavillion in Brighton, England.

And then there is the quite different history of the Catholic Church. Tupa is a priest of the Benedictine order, the oldest western monastic order, founded in the sixth century A.D. and named after Saint Benedict (c. 480–547). The California missions were founded primarily by friars of the Franciscan order named after Saint Francis (c. 1182–1226), an Italian saint of the early thirteenth century; they are comparative upstarts in Catholic history.

But history aside, Father Tupa brings to the canvas the structured discipline of an artist who, for over a quarter century, has explored the nature of spirituality. He is an artist whose powerful spiritual vision is infused and inspired by such varied sources as early Christian iconography, Christian graffiti in the catacombs of Rome, Kabalistic mysticism, Russian icons, Paleolithic art, and fertility images. This rich visual, spiritual, and artistic background of Father Jerome Tupa, speaks to us in his paintings of the California missions.

The title for this particular exhibition, *An Uncommon Mission*, was chosen for a number of reasons. The paintings in this series are unlike any other mission paintings by any other artist. Nor are they like any of Tupa's earlier paintings. The mission series was Tupa's first large-scale commission. Neither he nor Mervyn's California could have foreseen exactly the outcome of the project. There was simply a goal: paintings of all twenty-one missions. With the subject of the paintings chosen for him, Tupa was required to shift his focus away from man's internal spiritual quest and to observe, with the eye of an artist, the concrete products—the physical structures— of a long-gone attempt to spread Catholicism to the New World. *An Uncommon Mission* presents for the first time the results of this physical and spiritual pilgrimage to the California missions.

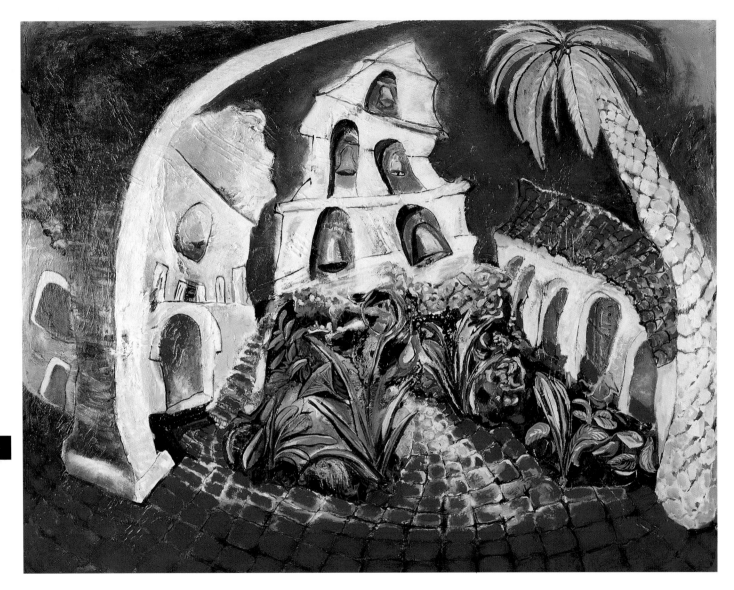

CLOISTER AND BELL TOWER

84 x 108 inches

Oil and wax medium on canvas, 1997

SAN DIEGO DE ALCALÁ, the first of the California missions, was actually the last visited by Jerome Tupa on his journey. South of San Juan Capistrano, Tupa was astonished by the tropical quality of his surroundings. The focus of this composition is the multileveled bell tower as viewed from beneath an arched portico. Brilliant red tiles in the foreground sweep in like waves, pushing the viewer forward into the composition. The tiles forming the pathway to the bell tower are tinged with a glowing yellow, and lead into a verdant garden. Both the Mission San Diego de Alcalá and the tower arc to the right, a movement strengthened by the arcade and balanced by the massive palm tree. Physical structures and plant life all seem to sway in an almost musical manner. The jewel-like surface of the painting is set against a rich, ocean-blue background.

Grant, O God of compassion,
that all who pass by this mission
may be touched by the example
of San Diego de Alcalá who
served Christ in the poor and
needy. Help us to become holy
and humble in your service.

II

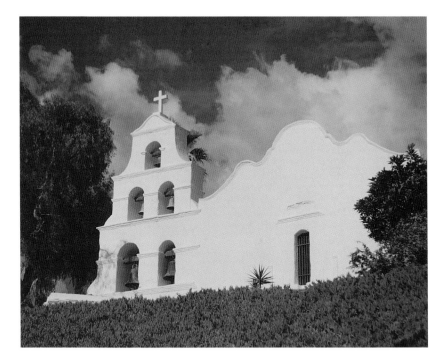

Father Junípero Serra founded San Diego de Alcalá, the first in the chain of California missions, on July 16, 1769. Originally the Mission San Diego de Alcalá was located on the Presidio Hill above Old Town. Five years later, it was relocated to a site six miles down the river where there was more land for cultivation, and where fewer problems might arise among the Indians and soldiers garrisoned in the settlement. The mission was named for Saint Didacus, (in Spanish, Diego), a fifteenth-century observant Franciscan missionary who was known for his work among the poor in the Canary Islands.

This painting is one of two in the exhibition (along with that of San Francisco de Asís) in which Tupa incorporates wax as part of the painting medium. The technique he uses, though not a true encaustic, gives the surface of the painting a more tactile sheen. Using wax allows Tupa to create surface details with a three-dimensional richness and brilliance; the painting acquires an inner glow.

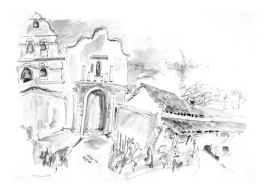

CHURCH, BELL TOWER
AND CLOISTER
29 ½ x 41 ½ inches
Watercolor/pen and ink on
paper, 1997.

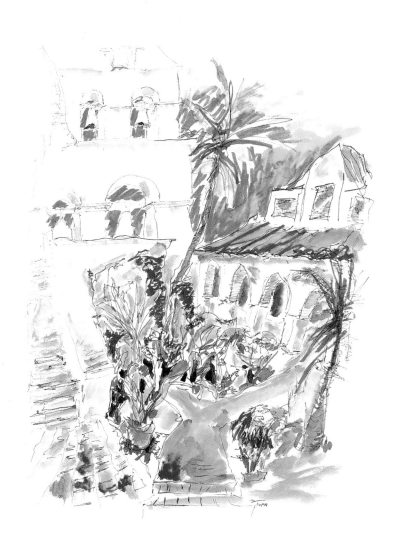

CLOISTER GARDEN
29 ¾ x 22 ¼ inches
Watercolor/pen and ink
on paper, 1997.

13

SAN DIEGO DE ALCALÁ

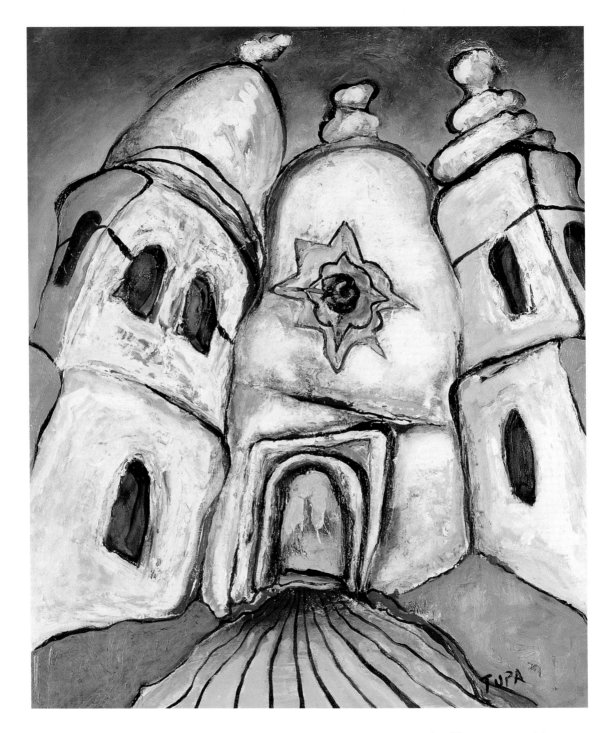

An Uncommon Mission

A GRACEFUL PATH

36 x 30 inches
Oil on canvas, 1998

BECAUSE OF THE WINDING residential roads of Carmel, it is easy to miss the Mission San Carlos Borromeo de Carmelo. This mission has been called the gem of all the missions and is startling in its lush beauty, Moorish gardens, and gnarled trees.

When Jerome Tupa discusses this painting a frown creases his brow, and his opening comment is terse: "It was too beautiful to paint." Tupa is often reluctant to attach words or experiences to particular paintings, but he confides that what he found most distracting about the Carmel mission were the great swaths of bougainvillea that decorate the structure and gardens and made it difficult for him to focus on the actual mission.

May we who visit this mission
be inspired by the example of your
friend and faithful servant Carlos,
to serve the widow and orphans
and all in need.
Through His intercession may we
know the great love of God
that stirs hearts to service.

15

STEEPLE/CLOISTER
AND BOUGAINVILLEA
18 x 24 inches
Watercolor/pen and ink
on paper, 1997.

That the overall prettiness of the mission surroundings was a distraction to Tupa is apparent in the soft, almost impressionist watercolors created in situ at the mission. The building seems to dissolve into a patchwork of muted pastels, which hint at the structure without clearly defining it.

In contrast, the oil painting has a solidity not present in the watercolors. Rather than focusing on the Moorish gardens or the swaths of bougainvillea, Tupa creates a mission façade composed of three distinct, organic pieces that

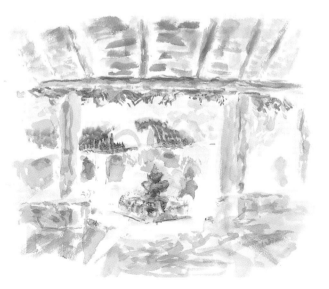

VIEW FROM THE
CLOISTER WALK
18 x 24 inches
Watercolor/pen and ink
on paper, 1997.

Father Junípero Serra found-
ed the Mission San Carlos
Borromeo on June 3, 1770, at the
Presidio in Monterey. San Carlos
Borromeo was the second of the
California missions, founded less
than a year after the Mission
San Diego de Alcalá. In 1771, the
mission was moved to Carmel
and was from then on referred
to as San Carlos Borromeo de
Carmelo. The mission is named
for sixteenth-century cardinal
and archbishop of Milan, Saint
Charles Borromeo (1538–84).
Charles Borromeo was a popular
Counter-Reformation saint who
had been canonized in 1610 for
his exemplary charity and care
for the poor and sick of Milan.

lean toward one another rather like giant
playing pieces on a chess board. The path into
the main entrance is golden in the foreground,
turning to pink and then brilliant red as it
enters the church, where it picks up the pink-
and-gold glow of the mission walls. The deep
green of the lawn and the rich cerulean blue of
the sky anchor the mission and entrance path
in space.

SAN CARLOS BORROMEO DE CARMELO

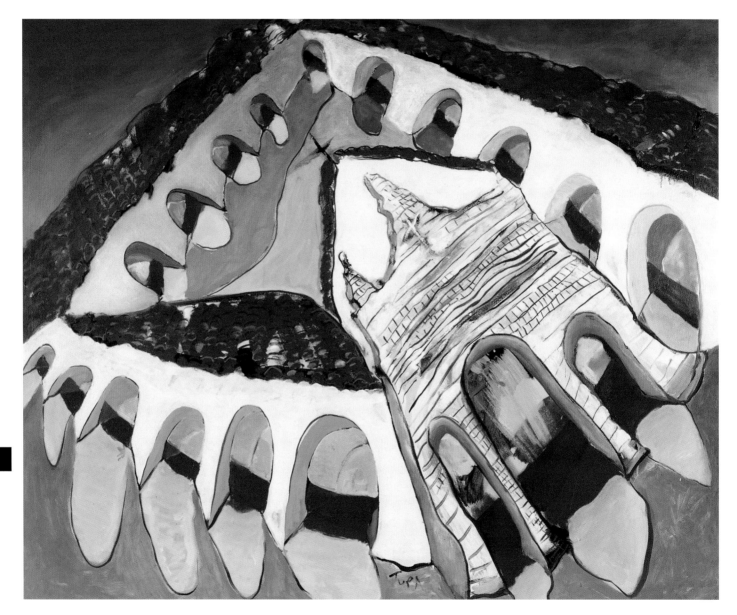

18

CLOISTER WALK

48 x 59 inches
Oil on canvas, 1998

ONCE A FRANCISCAN RETREAT, the Mission San Antonio de Padua now sits in the middle of a military reservation. In the summertime, the sun and heat are inescapable except within the confines of the mission and the arcades that surround it. San Antonio de Padua is not the easiest mission to get to, and yet of all the missions, it was one of the earliest to receive the attentions of historic preservationists. It has been rebuilt and reorganized. And now signs of all shapes and sizes alert the visitor to its past prosperity and importance.

On most occasions, Jerome Tupa's on-site sketches of individual missions are very different from the carefully crafted oils he painted in his studio in Collegeville, Minnesota. The contrast is readily apparent when the watercolors of San Antonio de Padua are compared with the oil compositions. While visiting the mission, Jerome Tupa described himself as feeling that

All life and all holiness come from you,
God, ever faithful and true.
Saint Antonio was touched by the
gospel of love to serve people
with the extraordinary power of
conviction that comes from faith in
the holy scriptures.
Help us to be hearers and doers of
the Word.

19

Father Junípero Serra founded mission number three, San Antonio de Padua, on July 14, 1771. A structure has existed on the present site since 1773. But because of the obscure location of this mission, twenty-seven miles northwest of Bradley, California, the buildings fell into ruin after secularization. Since then the site has been historically reconstructed. The mission was named for the thirteenth-century Franciscan Saint, Anthony of Padua, a Doctor of the Church, who had been a friend and disciple of Saint Francis, the founder of the Franciscan Order.

the mission was "empty of purpose." Perhaps reflecting this feeling, the watercolors he painted at the mission are gentle and restrained, delicate in form, and essentially subdued in color. *Cloister Walk*, with its riotous color, is much bolder in concept and actuality than the sketches that preceded it.

In *Cloister Walk* Tupa chooses a bird's-eye view of this mission. The artist's eye hovers over the mission taking in the entire structure, seeing it from inside and out. The arcades, with their characteristic red tile roofs, provide the solid framework for this painting. The brick mission façade, with its triple archways, seems to shimmer, appearing insubstantial in comparison to the clean, whitewashed walls of the adobe arcades. The brick superstructure obviously made a visual impression on Tupa, one which is hinted at in the wavy horizontal lines, and short, sharp verticals that decorate the façade. The double crosses, and one on the

CHURCH FAÇADE WITH THREE CACTI
20 ³/₄ x 30 inches
Watercolor/pen and ink
on paper, 1997.

façade, one on the elevated roof of the mission building beyond the façade, seem to waver and disappear in the heat.

Tupa's strength as a colorist is apparent in this painting. The red of the tiles is echoed in the blood red shadows of the cloister walk. The thick walls of the arcade arches in the foreground are painted a brilliant green and cast golden shadows. Throughout the painting complementary colors play off one another,

reds driving greens to full intensity, deep blues, contrasting with pulsing orange, and everywhere, golden yellow accents. Occasional flashes of aquamarine (in front of the arcade at the top of the painting) and cerulean blue and pink (in the façade and its arches) indicate the places at the mission where the sun's force is less strong. Tupa's Mission San Antonio is a solid grid of rich, deep color.

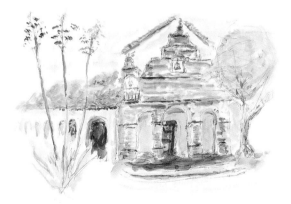

CLOISTER AND CHURCH
21 x 30 inches
Watercolor/pen and ink on
paper, 1997.

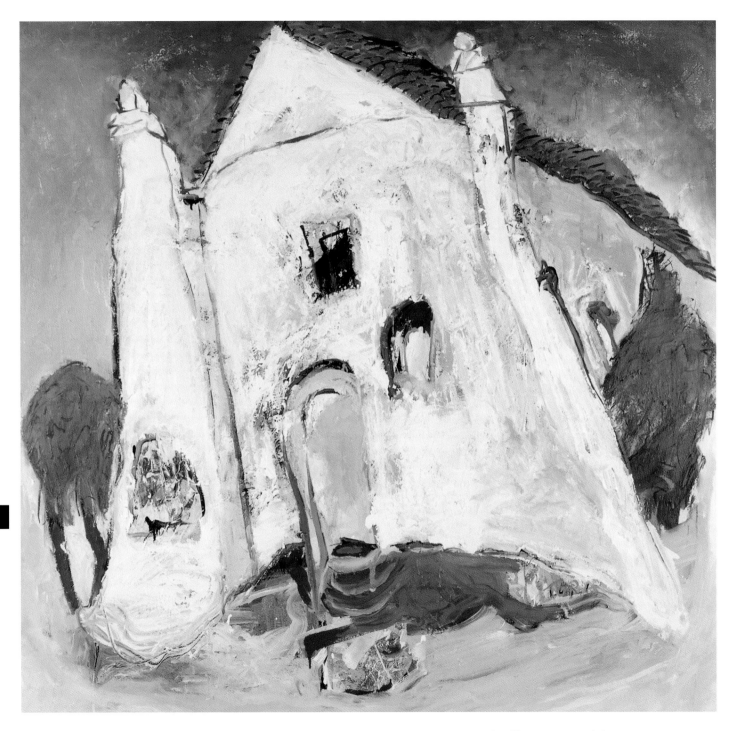

An Uncommon Mission

A GOLDEN ENTRY

46 1/2 x 48 inches
Oil on canvas, 1998

ONE OF THE HARDEST THINGS to overcome in a pilgrimage to the California missions is a sense of sameness. After a few days, the visitor, whether tourist or artist, comes to recognize specific architectural features, and a certain musty smell. Even the items displayed on shelves or in showcases are similar from one mission to the next. Historically this "sameness" had a functional purpose. The Catholic Church had a plan for the missions, and while recognizing topographical and climatic variation in different locations, the missionaries adhered to this plan. The Mission San Gabriel Arcángel is distinct, and *A Golden Entry* is in some respects also distinct from the other paintings in this series. Architecturally this mission has an unusally Moorish appearance that reflects the influence of its cleric, Father Cruzado, who was born and raised in Cordova, Spain. Tupa hints at these architectural differences, recording the capped buttresses at the tops of the towers to either side of the façade.

Bless the Lord, all you angels of God:
you that are mighty in strength
and execute God's word,
listening and obeying
the voice of God's orders.
Bless the Lord, O my soul:
and let all that is within me
bless God's holy name.
You chose the archangel Gabriel from
among all other angels,
to announce the mystery
of Your Incarnation;
grant in Your mercy that all who
visit this mission in thought or in
deed may feel the strength
of Gabriel's protection.
You who are God, living and reigning
forever and ever.
Amen.

23

The main difference between this painting and the others of the California missions series is how closely it seems to reflect elements of Tupa's earlier works. Architecture and landscape are less important in this composition than is the massive sense of form in the monolithic structure that threatens to overwhelm the canvas. Two elements that inform Tupa's earlier work—the use of gold leaf at the bottom of the tower and on the steps, and the *sgraffito* elements related to Christian graffiti found in the catacombs—appear quite naturally here. The title of this painting, *A Golden Entry*, may have been inspired by one of his pen and ink drawings done at the mission. In these simple pen drawings, the only touches of color appear in the trees flanking the mission, highlighted with deep red on the right, and in the golden door,

The Los Angeles area is home to several missions. The Mission San Gabriel Arcángel, located in San Gabriel, was the fourth mission, founded on September 8, 1771, by Fathers Pedro Cambon and Angel Somera. Because of its current urban surroundings, it is hard to imagine the importance of this mission in the early development of agriculture and ranching in California. The mission is named for the Archangel Gabriel, the messenger angel, who appears in both the Old and New Testaments, and is best known as the angel who brought the young Virgin Mary the news of Jesus' coming birth.

AN UNCOMMON MISSION

windows, and roof. In the oil painting, the golden door becomes an amorphous gold shape in the doorway to the mission. Tupa also uses touches of gold leaf at the bottom of the steps. To a certain extent in this painting more than any of the others, the medium is the message. Tupa simply paints. Looking closely at the composition reveals layer upon layer of color. Tupa works and reworks the surface of the painting until it is finished—not, as he himself has stated, until he is completely satisfied with the painting, but until it is finished.

CHURCH FAÇADE
29 x 30 inches
Pen and ink with colored ink on paper, 1998.

SOUTHERN VIEW
WITH THREE PALMS
29 1/2 x 41 3/4 inches
Watercolor/pen and ink on paper, 1998.

SAN GABRIEL ARCÁNGEL

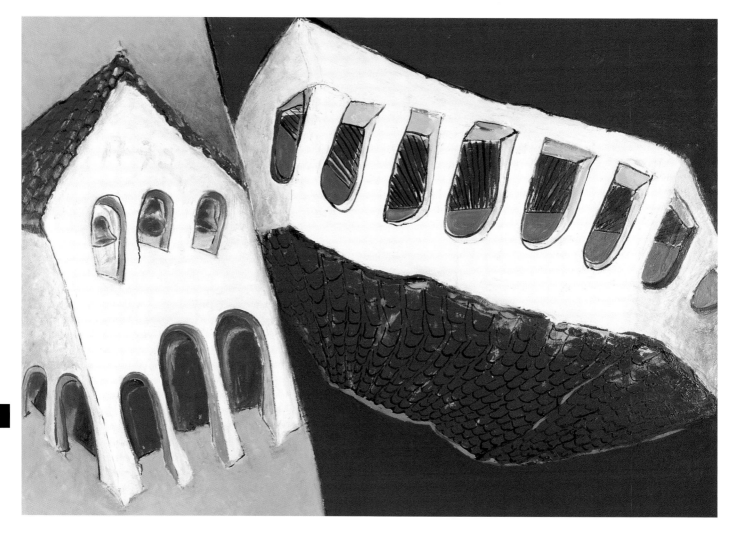

UPS AND DOWNS

42 1/8 x 60 1/4 inches
Oil on canvas, 1998

ONE OF THE MORE DIFFICULT missions to isolate from its contemporary surroundings is the Mission San Luís Obispo, which sits in the middle of the city of San Luís Obispo at the junction of two busy streets. On a sunny summer day, the mission is surrounded by activity; people strolling, children playing, tourists staring, and skateboarders navigating tricky turns and thundering down steps. Jerome Tupa's watercolors of the mission—which are in fact one of a very small number of works he did using marker and pen and ink on paper in addition to watercolor—depicts the mission completely isolated from its busy surroundings. The colors of the sky, roof tiles, and archways are indicated in marker, the pen and ink providing structure, and the watercolor hinting at form. It is hard to find any connection between these watercolors and the final oil. The watercolors are impressions made and recorded by Tupa, interesting as works and documents in

Praise, honor, glory be to You,
God of endless ages.
The blessed halls of heaven resound
with joyous hymns to Your name.
May all the earth be given to echoing
that praise which blessed Luís sings
for ever in Your presence.

27

their own right, but by no means studies for the final oils.

Ups and Downs is a curious painting. Two structures, the mission church and the cloister, form distinct parts of this horizontally oriented composition. The larger cloister is set against a background of deep red; the smaller church façade with its red bells and echoing red-shadowed arches, is set against a deep golden yellow. The two are separated by clear diagonal

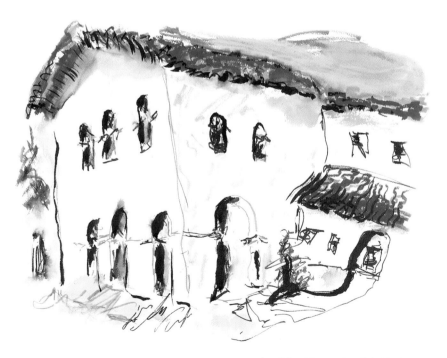

AN UNCOMMON MISSION

28

demarcation. Whichever way the painting is turned, and Tupa has not decided which end is up, one structure is right side up and the other upside down. Tupa here explores structure and color. This is the only painting of the twenty-one oils lacking a geographical orientation of some kind. It is also the only one without sky or

San Luís Obispo de Toloso is the fifth in the chain of California Missions, founded by Father Junípero Serra on September 1, 1772. The mission was named for an important Franciscan saint, Louis, Bishop of Toulouse. Louis was the second son of Charles II, King of Naples. To the dismay of his family, Louis renounced the throne in favor of his younger brother Robert and joined the Franciscan order. Louis died at the age of 23 in 1297 and was canonized that same year.

background. The necessary and familiar blue that is so striking in these compositions, can here be viewed through the archways of the cloister. This gives the structure an insubstantial quality, and outlining elements in the mission church define the building and give it a stability Tupa denies to the cloister.

SAN LUÍS OBISPO DE TOLOSO

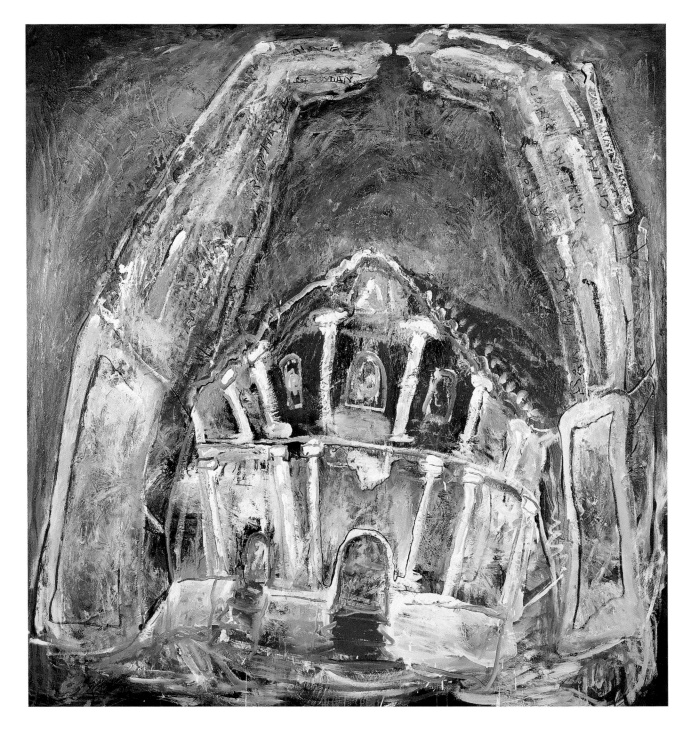

An Uncommon Mission

LOVING TOWERS

82 x 86 inches
Oil and wax medium on canvas, 1997

TUPA BEGAN PAINTING *LOVING TOWERS* in the summer of 1997, soon after he had returned to his studio at St. John's University from a sabbatical leave in Greece and Rome. It is one of the two works in the series (the other, *Cloister and Bell Tower*, of San Diego de Alcalá) using a mixture of pigment, oil, and wax as the medium rather than oil paint alone on canvas. The addition of wax as a component of the painting medium adds a rich texture to its surface, as well as a certain brightness overall. Even in a color reproduction, it is easy to see how Tupa worked and reworked the surface of this composition. This style of painting, with its complex layering and often-frantic movement is similar to the type of brushwork explored by Tupa in his series from the early 1990s. The graffiti-like, calligraphic elements that can be seen running vertically up the sides

*Holy Mary, the Queen of heaven
and mistress of the world,
stood by the cross of our Lord
Jesus Christ, full of sadness.
May all who pass by the Camino Real
see and attend to the sorrow
of all mothers who see their
children lost, condemned, or
suffering in this world.
May we imitate Mary who accepted
all with the knowledge that
God's way was the road
to eternal glory.
We ask this through Christ,
the son of Mary and God the Father.
Amen.*

31

The Mission San Francisco de Asís, better known as Mission Dolores, is located in downtown San Francisco. It was the sixth mission, founded on June 29, 1776, by Father Francisco Palóu. The mission is named for Saint Francis of Assisi (1182–1226), the founder of the Franciscan Order. The more common name for the structure, Mission Dolores, comes from a small stream that flows near where the mission was built. The leader of the expedition who chose the sites for the presidio and the mission, in what would later become San Francisco, named the stream Arroyo de los Dolores, because it was discovered on the feast day of Our Lady of Sorrows—in Spanish, Nuestra Señora de Dolores.

of the towers are also found in his earlier work and relate to Tupa's interest in the graffiti found in the Christian catacombs outside of Rome. Their appearance in his works here, to a certain extent, form his contemporary continuation of a motif that appears in the earliest Christian paintings known to man. They are an old-world link to this new-world structure.

AN UNCOMMON MISSION

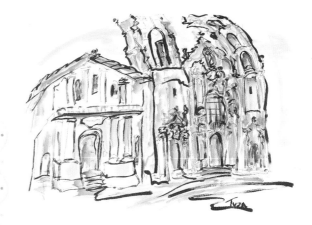

FAÇADES WITH BENDING TOWERS
29 ¹/₂ x 41 ¹/₂ inches
Watercolor/sumi ink
on paper, 1998.

The curious structural elements, which lend the painting its title, *Loving Towers*, do not actually belong to the mission chapel, as the painting indicates, but are part of the large stone parish church that was built next door to the mission. In one of the watercolors, entitled *Façades with Bending Towers*, the small mission chapel, squat and stable, is juxtaposed with the pseudo-Baroque parish church that trembles and bends. Here we already see the impetus for the towers that curve lovingly above the smaller building in the final oil painting. In a second watercolor, entitled *Leaning Towers of San Francisco*, Tupa continues exploring the idea of the two towers surrounding the small mission. Yet in the watercolor the towers are still recognizable as Neo-Baroque architectural structures rather than the abstract organic shapes that appear in the oil.

LEANING TOWERS OF
SAN FRANCISCO
29 ¹/₂ x 41 ³/₄ inches
Watercolor/pen and ink on paper, 1998.

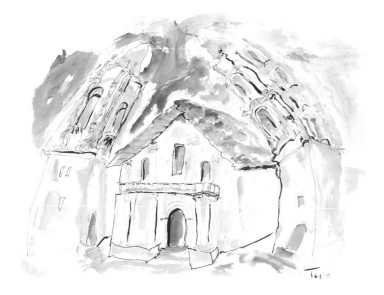

SAN FRANCISCO DE ASÍS (MISSION DOLORES)

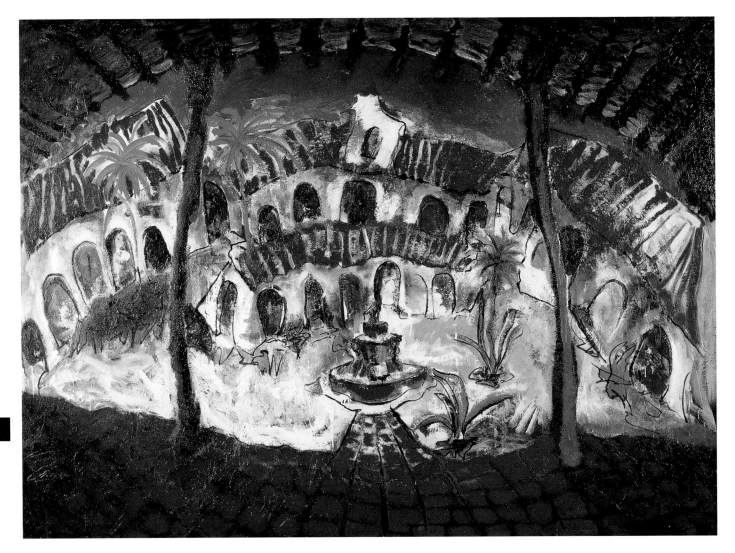

AN UNCOMMON MISSION

CLOISTER WALK

62 x 86 inches
Oil on canvas, 1997

IN *CLOISTER WALK* Tupa uses familiar devices to frame his lush composition. He himself says he was startled when he reached San Juan Capistrano to notice how lush and tropical the landscape appeared, almost as if he were suddenly in a different part of the world. The psychology of the assignment he had taken on must be noted here. When Tupa arrived at the Mission San Juan Capistrano after several weeks on the road, the end of the first part of his project—visiting each mission—was finally in sight. After these next three missions he could go back to the studio and start painting. Taking these elements into account—the change in the landscape and the end of the journey—a freedom of movement and change in the quality of color in the watercolors made at San Juan Capistrano and San Diego can be understood. This new tropical sense results in a different form and a richer color in the paintings of the

You gave to blessed Juan de Capistrano courage and strength to follow his faith in all things.
By his intercession may we who visit this sanctuary avoid the snares of our spiritual enemies and deserve to receive from You, God of love, the crown of glory.
We ask this through Jesus our Lord.
Amen.

35

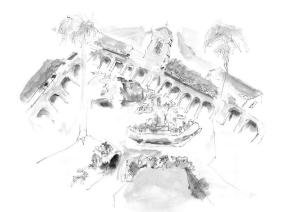

CLOISTER, FOUNTAIN AND
BELL TOWER
29 ¹/₂ x 41 ¹/₂ inches
Watercolor/pen and ink
on paper, 1997.

BELL TOWER, CLOISTER
AND TWO PALMS
29 ³/₄ x 21 ¹/₄ inches
Watercolor/pen and ink
on paper, 1997.

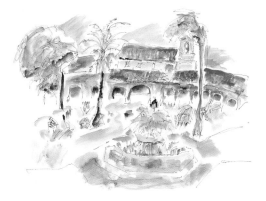

CLOISTER/BELL TOWER/
FOUNTAIN/ THREE PALMS
29 ¹/₂ x 41 ¹/₂ inches
Watercolor/pen and ink
on paper, 1997.

southernmost California missions (San Juan
Capistrano, San Luís Rey, and San Diego).

Tupa frames his view of the fountain,
garden, and buildings of San Juan Capistrano
as seen from beneath an overhang. Slender
blue posts, which support the overhang and pin
down the brilliant red tile pathway, add a
strong vertical element. The posts help to

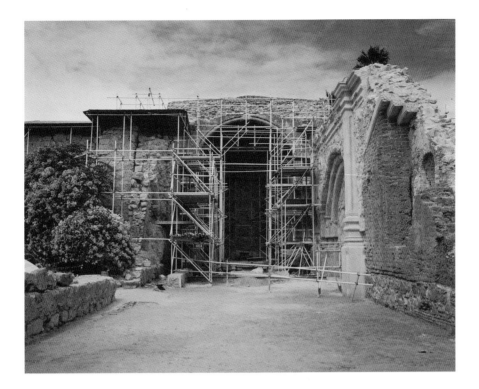

moderate the undulating waves of golden adobe; purple, blue, and magenta arches; red tile roofs; and brilliant green palm leaves are all set against a brilliant blue sky. The supports serve as punctuation marks, allowing the eye to rest for a moment before continuing through the colorful landscape. Of all the paintings in the series, this is the most lyrical.

The Mission San Juan Capistrano is perhaps the most famous of the California missions in modern times. It was the seventh to be founded, on November 1, 1776, by Father Junípero Serra. The mission was named for the fourteenth century Italian Franciscan missionary and theologian, John of Capistrano.

SAN JUAN CAPISTRANO

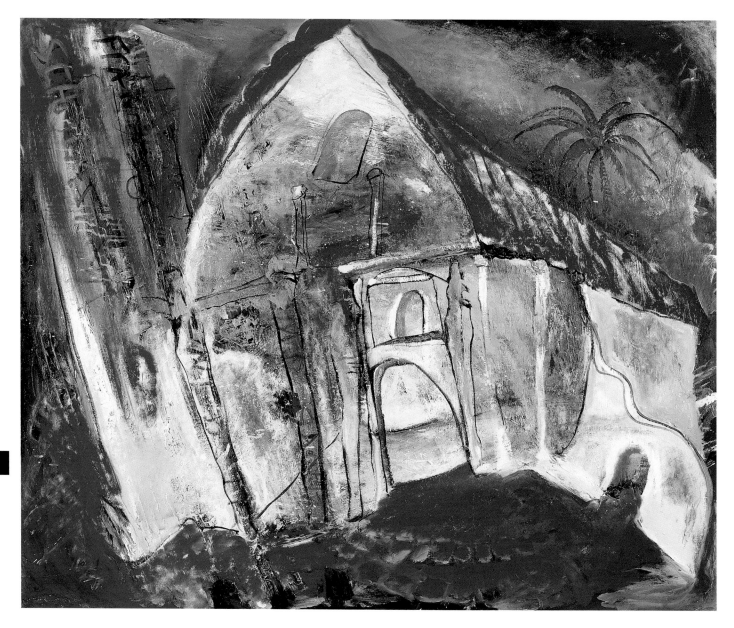

AN UNCOMMON MISSION

TOWER AND CHURCH: A RED WALK

63 x 76 inches
Oil on canvas, 1997

TOWER & CHURCH: A RED WALK, one of the early paintings in the mission series, has much in common stylistically with *Loving Towers,* Tupa's oil of San Francisco de Asís. Here too, Tupa practices his complex layering of paint. Thin black lines define the form of the Mission Santa Clara and the two palm trees, barely discernible as such, that stand in the foreground. The mission is a hunched form, planted tentatively on the red walk from which the painting takes its title. To the left-hand side of the composition, the bell tower rises and then seems to dissolve in a riot of color as it ascends. Graffiti elements like those in *Loving Towers,* only less legible, climb the tower vertically.

One palm behind the mission, isolated in a small corner of blue sky, and hedged in with red and gold, is the lone recognizable form, overwhelmed by the blazing colors surrounding it

God of all creatures.
Your love for all women is shown
in the choice of your closest friends,
Martha and Mary.
Through the prayers of Santa Clara,
a woman who dedicated herself to You
by the signs of poverty and prayer,
help us to be ever mindful of the needs
of others, especially those who suffer
from hunger or war.

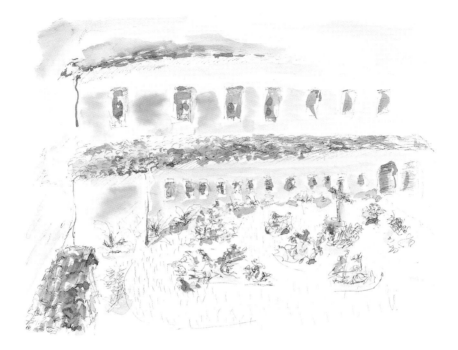

FAÇADE AND GREENERY
15 x 20 inches
Watercolor/pen and ink
on paper, 1997.

on all sides. Tupa reduces the rich ornamentation of the church façade to a bare minimum. Architectural features become mere platforms for explorations in color and shape. The red walk becomes a way for the spectator to visually circumnavigate the structure and comprehend it as a unit. In later paintings, Tupa more obviously dissolves the walls of the mission to give the viewer both exterior and interior "views" of a structure at one same time. Here we begin to get the first real sense of the dissolution of surface form.

The present-day mission of Santa Clara de Asís is located on the campus of Santa Clara College. When it was founded on January 12, 1777, by Father Junípero Serra, the mission was located on the banks of the Guadeloupe River, and only later was it moved to its present site. The mission visitors see today is a historic recreation of the fifth mission, which was originally built in 1825–remodeled twice, burned down in 1926, and again rebuilt in 1929. The mission was named for Saint Clare of Assisi (c. 1194–1253), the founder of the Order of Poor Clares, the female branch of the Franciscan order.

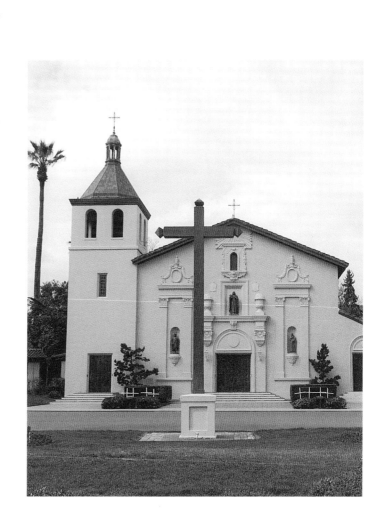

SANTA CLARA DE ASÍS

42

BENT TOWER

46 x 38 inches
Oil on canvas, 1998

OF ALL THE PAINTINGS in the exhibition, that of the Mission San Buenaventura gives the impression of being the most formally structured. This is a carefully crafted painting where Tupa's controlled brushwork balances and contains the complex color scheme at work. Tupa's art is never about illustration, but about creation, and Tupa's painting of the Mission San Buenaventura is about reincarnation in a visual sense.

A photograph of the façade and bell tower of the Mission San Buenaventura reveals a structure decorated in severe geometric fashion. The façade is made up of a series of rectangles and triangles, while the tower is a set of three rectangles—the upper two pierced by arches—with a striped dome top capped with a cross.

O God, You reward faithful souls;
grant that we may obtain peace
and serenity through the visiting
of this Mission San Buenaventura
on the holy road of pilgrimage,
the Camino Real.
Through the intercession
of San Buenaventura may we always
follow Your ways in this life
and thus gain eternal happiness.
We ask this through our Lord Jesus Christ,
who lives and reigns forever and ever.
Amen.

43

The Mission San Buenaventura was the last mission founded by Father Junípero Serra, on March 31, 1782. Like many of the missions, this one suffered from fires, earthquakes, and pirate attacks. It remained prosperous, however, and is renowned for its gardens. The mission is named for the thirteenth-century Franciscan theologian Saint Bonaventure (1221–1274). One of the legends of how Saint Bonaventure got his name claims that Saint Francis had seen him as an infant, recently recovered from a serious illness, and supposedly exclaimed at the child's recovery "O, what good fortune!"–In Italian, "O buona ventura!"

The river of red that flows from the outside of the building, up the steps, and along the entire length of the mission's interior organizes Tupa's architectural structure. The red defines and stabilizes. The segmentation into parallel lines of the mission's floor, walls, and ceilings is a stylistic device Tupa uses to indicate the viewer is seeing inside the structure. The walls have dissolved and only the severe geometric decoration of the façade is left, indicated by the

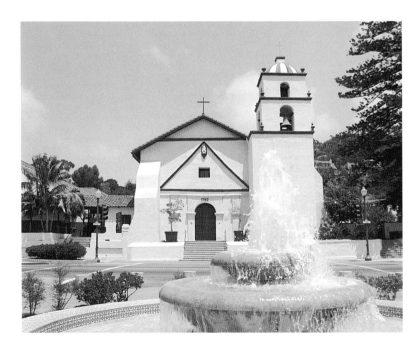

SCHOOL AND MISSION CHURCH
29 ½ x 41 ¾ inches
Watercolor/pen and ink
on paper, 1997.

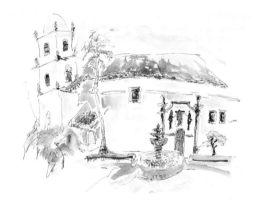

CLOISTER AND FOUNTAIN
29 ½ x 41 ½ inches
Watercolor/pen and ink
on paper, 1997.

broad swaths of white paint and, on the side, the buttresses supporting the red tile roof. Unlike the mission, the bell tower is a solid, albeit bending, structure. Instead of unrelieved white, the tower, pink on one side and blue in the shadow, is decorated with a series of shapes that may be symbols or may simply be shapes, according to the interpretation of the viewer.

SAN BUENAVENTURA

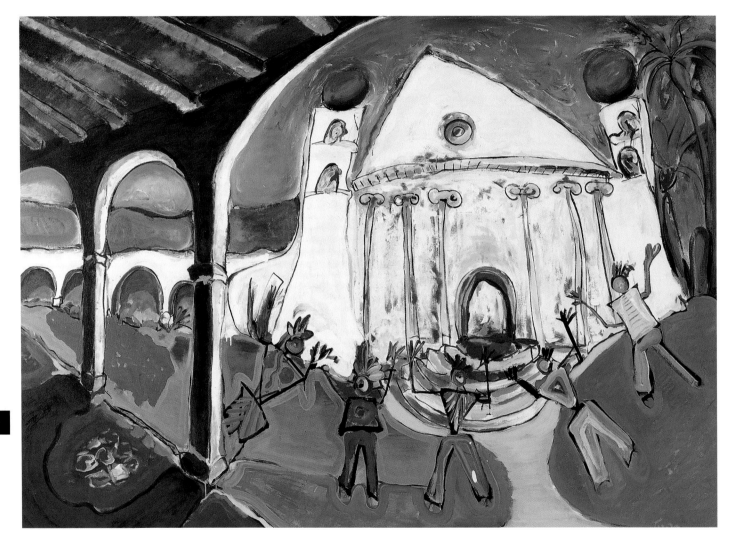

AN UNCOMMON MISSION

A CELEBRATION

62 x 86 inches
Oil on canvas, 1998

JEROME TUPA INVOKES the universally acknowledged right of artistic license in his re-creation of the Santa Bárbara mission, *A Celebration*. This is the only one of the California mission paintings that includes figures, Indian figures in masks dancing in front of the mission's grand neo-classical façade. In fact, there were no Indian dancers performing when Tupa visited the Mission Santa Bárbara, and they do not appear in his watercolors painted at the mission. It was about this time, however, a little over midway through his journey, that Tupa began to feel the human element was missing in his compositions. At one point he even contemplated having full-size, three-dimensional sculptures displayed in the galleries along with the paintings, an idea which ultimately proved too ambitious to be realized.

God of all life, we give You glory
and praise for Saint Barbara
and the triumph of her martyrdom
over the forces of oppression and death.
Protect us as we journey through life
that we may arrive on our heavenly
birthday filled with gratitude for life-
giving and life-affirming faith.

47

Tupa does take liberties with this mission, which is perhaps the most immediately recognizable of all of them with its oversized Ionic pilasters. A golden pathway leads the viewer's eye to the steps that expand forward from the façade like ripples from a pebble dropped into a pond. As in reality, pilasters

CHURCH VIEW FROM THE ARCH
29 ¹/₂ x 41 ¹/₂ inches
Watercolor/pen and ink
on paper, 1997.

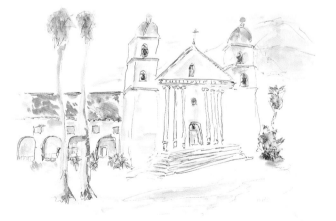

TWO PALMS AND CHURCH
29 ¹/₂ x 41 ¹/₂ inches
Watercolor/pen and ink
on paper, 1997.

AN UNCOMMON MISSION

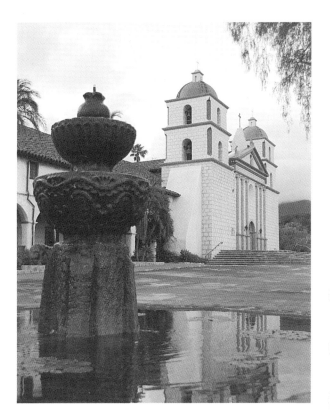

Mission number ten is the Mission Santa Bárbara, founded on December 4, 1786, by Father Fermín Lasuén. This is the fourth church on this site. The mission is named for a popular Christian saint, Saint Barbara, who was martyred for her faith in the third century.

decorate the entryway, but their Ionic capitals have grown and expanded in the painting. The stacked rectangular towers retain their shape but their half-dome tops are transformed into glorious red balls. Tupa gives the viewer a glimpse of the Mission Santa Bárbara from beneath an imaginary arcade; no such arcade exists that would give an artist this particular view of the façade. A particularly lovely passage is the curious rose-window pattern cast by the sun behind the arch in the left-hand corner of the painting. The two sides of the arch echo the verticals supplied by the twin bell towers. Between the two structures, cloister and mission, the schematic Indian figures dance across a landscape of peach tile and green lawn.

SANTA BÁRBARA

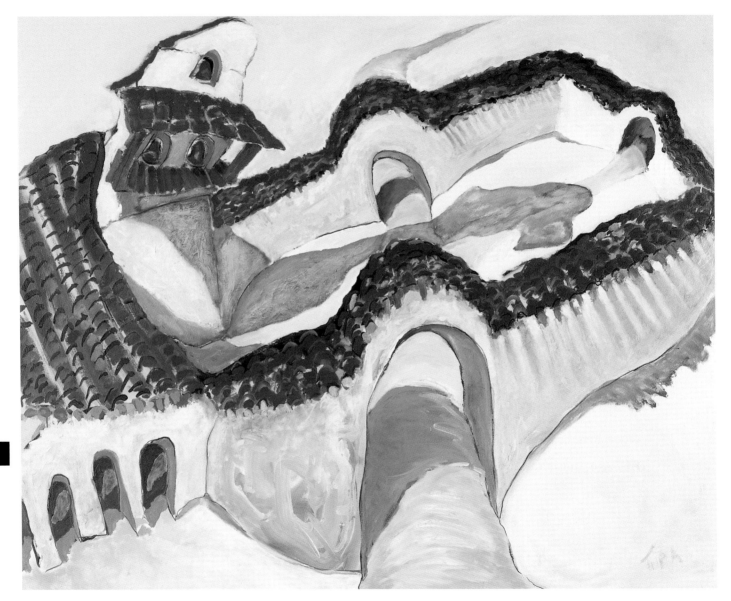

CLOISTER DOORS

48 x 59 inches
Oil on canvas, 1998

LIKE THE MISSION San Antonio de Padua, La Purísima Concepción is off the beaten track and has been turned into a showplace. The mission buildings sit on a flat piece of land with a ridge running behind them. Perched on this ridge, Jerome Tupa acquired his bird's-eye view of the arched doorways, directly opposite one another, that lead into and out of the small quadrangle. The golden yellow path between the two doors is broken only by the dark green shadows cast by the arches and the bell tower.

The walls of the quadrangle and the mission buildings ebb and flow. The red tile roofs and salmon pink adobe walls are set in brilliant contrast to dark blue and green shadows and the beige and gold landscape. The colors are approximately those used in the watercolors done at the sight, but in the final oil painting they are intensified: the pinks pinker, the reds deeper, the shadows rich and saturated with color. There is a strangeness in this

Almighty and everliving God,
You raised to the glory of heaven
this most pure and immaculate Mary,
the Mother of your Son Jesus.
Grant us pray, that our hearts
burning with the fire of charity
and love may give You glory
and aspire to raise all peoples
to unity with You.

51

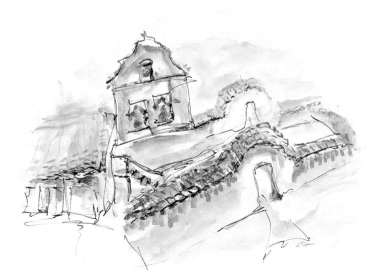

BELL TOWER AND CLOISTER
22 x 30 ¼ inches
Watercolor/pen and ink
on paper, 1997.

F ather Fermín Lasuén founded the eleventh mission, La Purísima Concepción, on December 8, 1787. The mission is dedicated to an idea rather than a person. It was named for the Immaculate Conception of Mary Most Pure—a religious concept that had been developing since the middle ages, that the Virgin Mary was free from the taint of original sin. This mission is unusual because its buildings string out behind the chapel rather than forming an enclosed area around a quadrangle.

52

AN UNCOMMON MISSION

composition, and despite the bright colors there is something mysterious and sterile in the desolate quadrangle populated only by the worn pathway and dark shadows cast by the bent bell tower. The path and shadows meet in the center of the quadrangle in an elegant, undulating shape of a cross. After the path leaves the quadrangle at the top of the composition it tapers off into the distance.

EL CAMINO REAL
22 x 30 inches
Watercolor/pen and ink
on paper, 1997.

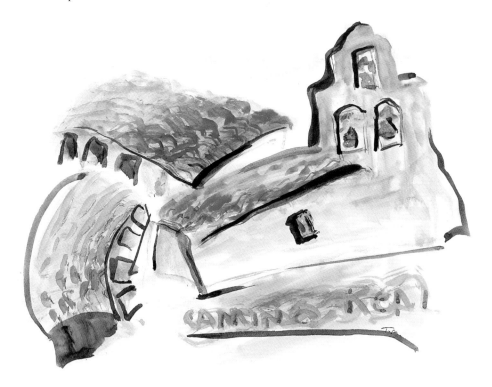

LA PURÍSIMA CONCEPCIÓN

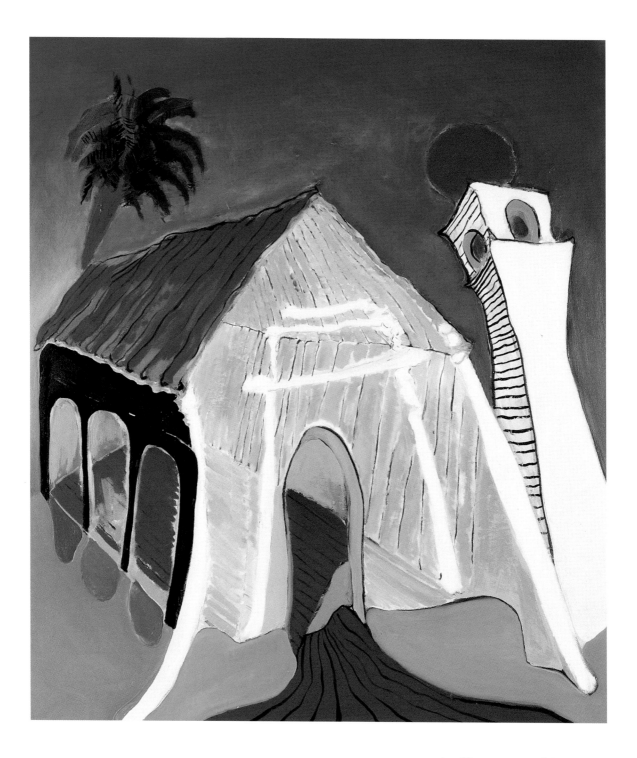

INSIDE AND OUT

46 x 40 inches
Oil on canvas, 1998

IN THIS PAINTING, along with the paintings of the Missions San Buenaventura, Santa Inés, and San Rafael Arcángel, Father Tupa explores the idea of dissolving the barriers that separate the inside and outside of the physical structures. The actual mission structure (a 1931 replica that is one third the size of the original mission church) is reduced to a series of simple geometric shapes.

The small buttress shapes at the sides of the façades bend outward, embracing the green lawn and the red pathway that flows into (or out of) the chapel. The three arches along the side seem to support the structure. The ubiquitous palm tree peers over the mission from the back, a paired vertical element with the tower on the right. As in the painting of the Mission San Francisco de Asís the towers lean in toward each other. The red-tiled dome of the tower here, like those in the Mission Santa

It is good to glory in the Cross of our Lord
Jesus Christ in whom is our
salvation, life, and resurrection;
by whom we are saved and delivered.
May God have mercy on us who come to
this place.
May God bless us; may God cause the light
of his countenance to shine upon us,
and may God have mercy on us
forever and ever.
Amen.

55

Father Fermín Lasuén founded Mission number twelve on August 28, 1791. The mission Santa Cruz is named Holy Cross; Catholics were encouraged to meditate upon the symbol of the cross Jesus was crucified upon. Today's structure, built in 1931, is a small replica of the original.

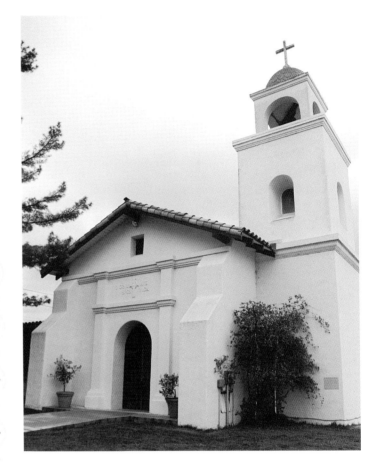

Bárbara, is transformed into a glowing ball of red, set against the blue sky. Tupa partially dissolves the solid walls of the façade leaving only the sky-blue three-dimensional arched doorway frame and the white amorphous outlines of architectural features. Consciously or unconsciously, they are transformed into a shape reminiscent of a Japanese doorway. Interiors are pink, gold, and red—pink for the roof, gold for the walls, and red for the floors—with one exception: where the floor is seen through the façade, the color is soft lilac and pink rather than deep blood red.

56

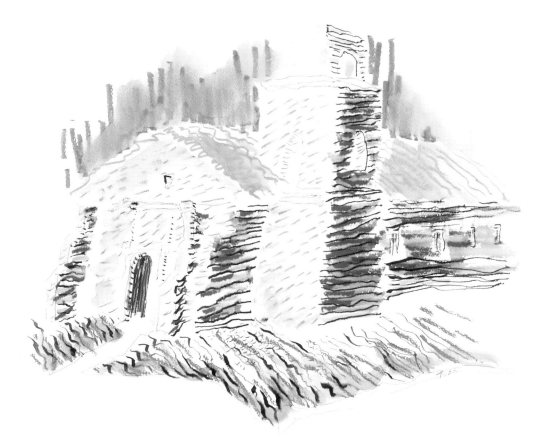

LAWN AND CHURCH
18 x 24 inches
Watercolor/pen and ink
on paper, 1997.

LAWN, TREE
AND CHURCH
18 x 24 inches
Pen and ink
on paper, 1997.

SANTA CRUZ

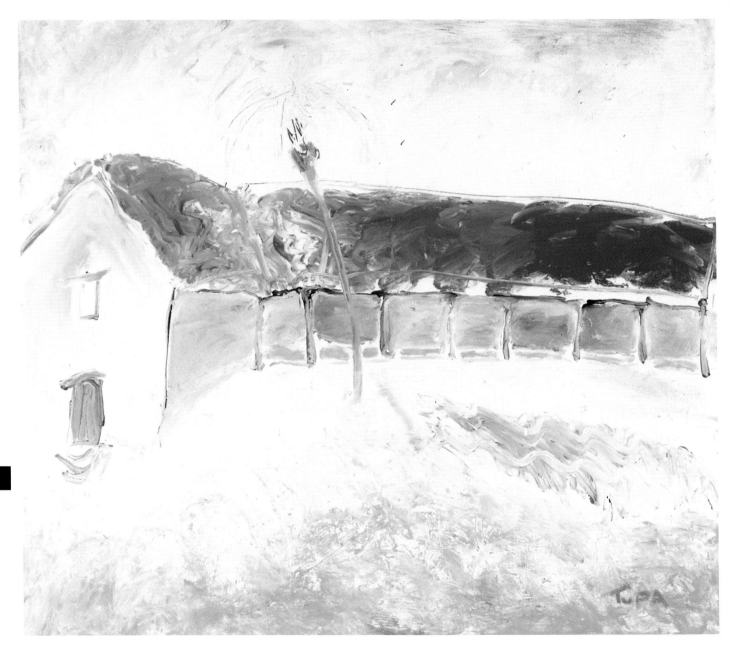

58

A DESERT PLACE

40 x 46 inches
Oil on canvas, 1998

THE PAINTING OF THE MISSION Nuestra Señora de la Soledad is the gentlest of all of Father Tupa's mission paintings. Though it is comparable in size to many of the others, there is a tentative, hands-off quality to this one. By his own account, Tupa was much affected by a sense of place. This is apparent in the tiny, soft watercolors of the Mission Soledad as well.

Of all the mission paintings by Tupa, this is the one that seems closely related visually to actual mission geography and history. This sad, impoverished mission in desolate surroundings has a sorrowful history. Mission Nuestra sits in the middle of lettuce fields, about three miles south of the town of Soledad. Of all the missions, it is the poorest, and Tupa was distressed by the surroundings.

You gladden our hearts O God by the
protection and prayers of Mary,
the Mother of Jesus, Your Son.
All nature is resplendent in Your great glory
and is raised up like Mary
who is as bright as the sun
and as fair as the moon.
May this mission be a reflection of
Your goodness and Your love for us all.

59

DESERT, CHURCH AND BUILDING
12 ³/₄ x 18 inches
Watercolor/pen and ink
on paper, 1997.

MISSION BARRACKS
12 ³/₄ x 18 ¹/₈ inches
Watercolor/pen and ink
on paper, 1997.

The mission, dedicated to Mary in her incarnation as Our Lady of Solitude, started out well enough and was originally prosperous but a series of floods destroyed buildings, and epidemics wiped out missionaries and Indians. Eventually only a small number of people remained at the mission and food was often scarce. In May 1835, the year the missions were secularized, Father Vicente Francisco de Sarría collapsed of starvation and

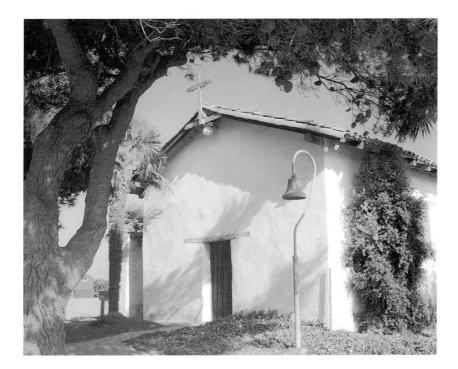

Father Fermín Lasuén founded the thirteenth mission on October 9, 1791. Mary is known by several names and designations in the Catholic Church, one of which is Our Lady of Solitude, and it is for this role of Mary that the mission was named.

died while saying mass. The 1950s left nothing of this mission but crumbling walls.

There is an ephemeral quality to Tupa's painting of the Mission Nuestra Señora de la Soledad. Colors, rich and deep in other paintings, are here washed out. This is, perhaps, Tupa's visual response to what he described as the oppressive heat, poverty, and quietude that surround the present-day mission.

CHURCH AND MISSION,
WITH TWO PALMS
12 ¾ x 18 inches
Watercolor/pen and ink
on paper, 1997.

NUESTRA SEÑORA DE LA SOLEDAD

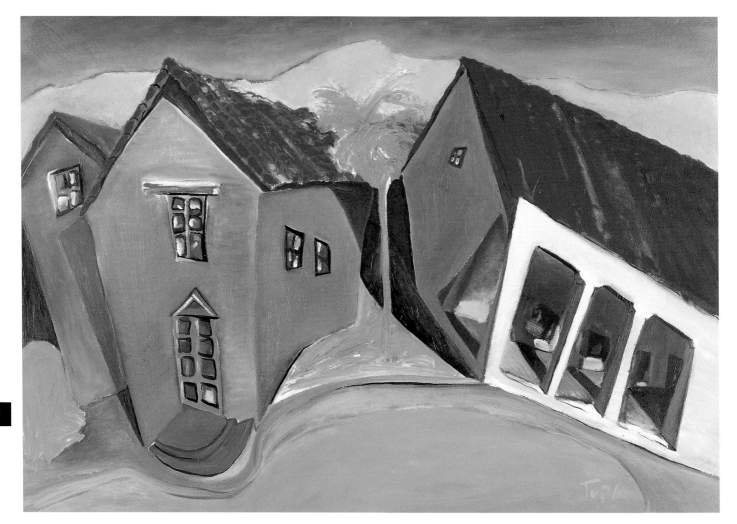

AN UNCOMMON MISSION

EVENING AT SAN JOSÉ

42 ¹/₄ x 60 inches
Oil on canvas, 1998

EVENING AT SAN JOSÉ was the very last of the mission paintings to be completed. This painting is different from the others in that it is useless to search the subtle pen and ink sketches Tupa created while visiting the mission for clues or hints at the final oil. Father Tupa was commissioned as an artist, not an illustrator, for these paintings. What makes this series of mission paintings different from the known series that preceded it is Tupa's life experience. These works are informed by his vision of the world. Tupa is a man who is at once artist and priest, professor and missionary. He resides in Minnesota but has lived and travelled in France, Italy, and Greece. In *Evening at San José*, Tupa confesses his color scheme was

*Oh faithful and ever loving God,
José was filled with that faith
which we celebrate as holy.
Faithful companion and guide,
unfailing protector of Jesus and Mary,
pray for us that we may be watchful
and patient parents and guides
of the souls entrusted to us.*

63

FAÇADE, BELL TOWER AND STEPS
18 x 14 inches
Pen and ink wash
on paper, 1997.

San José was the fourteenth mission and was founded on June 11, 1797, by Father Fermín Lasuén. It is named for Saint Joseph, Jesus' earthly father. The Mission San José was destroyed by an earthquake in 1868, and parishioners replaced it with a wooden neo-Gothic church built on the foundations of the old mission. In the 1980s the 100-year-old church was sold and moved to Burlingame and replaced with the present historical reconstruction of the 1809 mission.

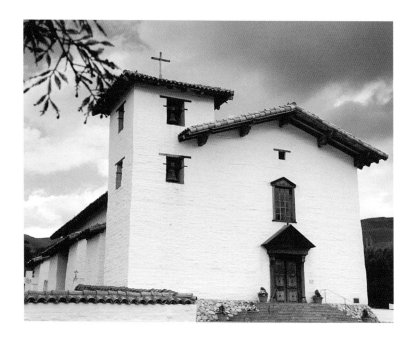

influenced by the knowledge that he was soon to travel to the Bahamas. Without that pivotal piece of personal information, the viewer would be forced to speculate endlessly about the joyous tropical character of this painting. The pink and orange mission, a far cry from the actual structure, and the tipsy cloister, are nestled between golden mountains, an orange road, and a green lawn.

CHURCH FAÇADE
AND TOWER
18 x 24 inches
Pen and ink wash
on paper, 1997.

SAN JOSÉ

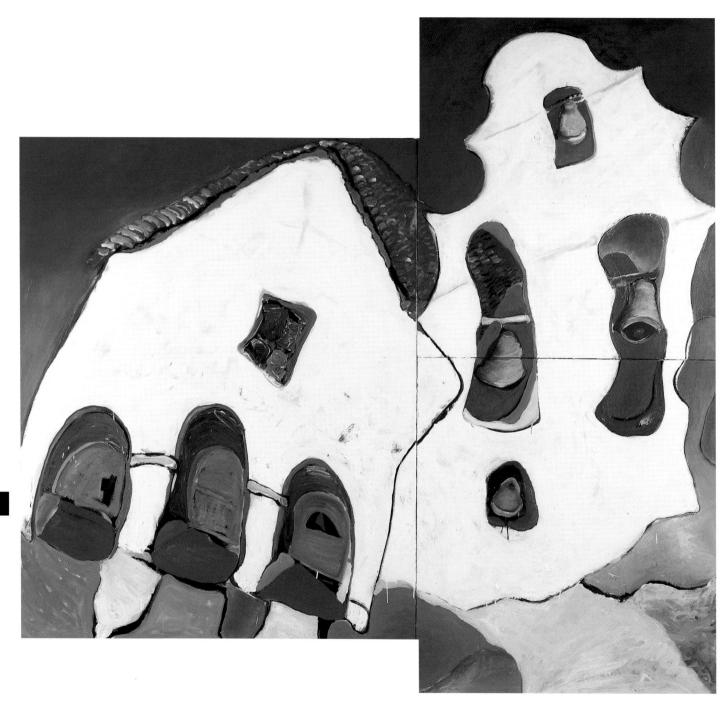

A SPIRITUAL MELODY: TRIPTYCH

59 x 48 inches, 36 x 40 inches and 36 x 40 inches
Oil on canvas, 1998

A SPIRITUAL MELODY: TRIPTYCH is, structurally speaking, the most complex painting in the series. The Mission San Juan Bautista, named for Saint John the Baptist, was the largest of the mission churches. Tupa focused on the curious juxtaposition of the mission chapel and the recently constructed belltower in a painting that is physically composed of three separate canvases. In medieval art, the triptych was a tripartite painting with a central panel and two side panels—each of which was independent; here Tupa gives us an updated tripartite division. The left, and larger, side of the composition is dedicated to almost all of the mission chapel. The right side of the composition is divided horizontally into two pieces: the

I have spoken your words before kings
and I was not ashamed:
I meditated on your commandments,
which I have loved exceedingly.
It is good to give praise to the Lord
and to sing Your name, O most High.
May the Camino Real and the visit to
this mission of San Juan Bautista
help us win Your salvation and peace
for all who search for Your word.
We ask this through Christ our Lord.
Amen.

67

CHURCH AND SMALL GATE
15 x 20 inches
Watercolor/pen and ink
on paper, 1997.

BELL TOWER AND
CHURCH FAÇADE
18 x 24 inches
Watercolor/pen and ink
on paper, 1997.

AN UNCOMMON MISSION

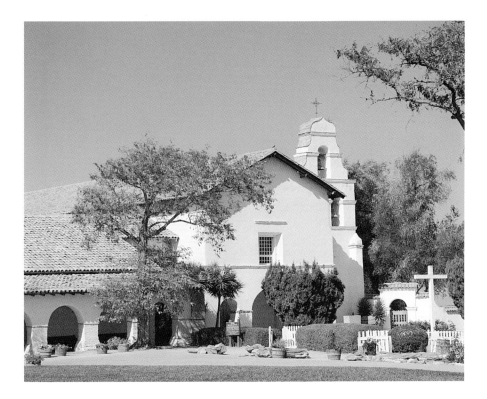

bottom and top of the bell tower. The divisions between the sections of the painting seem to occur almost at random. One corner of the chapel is separated from the rest of the structure; a bell is broken in half. But no single panel is complete without the others. In medieval art, parts can work independently of each other; in this painting, all parts are required.

The mission of San Juan Bautista was founded by Father Fermín Lasuén on June 24, 1797, fifteenth in the chain of California missions. The first church was finished the following year. The mission is named for St. John the Baptist, the forerunner of Jesus and first prophet of the New Testament.

SAN JUAN BAUTISTA

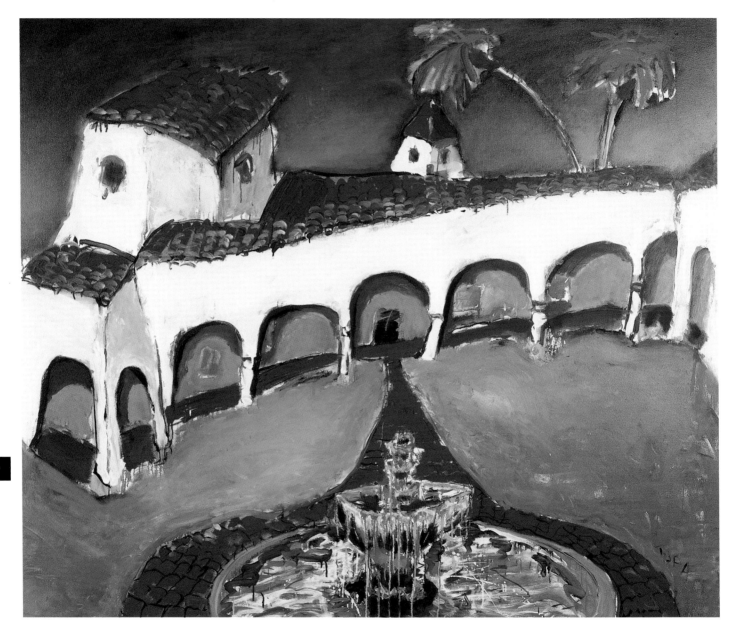

AN UNCOMMON MISSION

CLOISTER GARDEN

60 x 71 inches
Oil on canvas, 1998

TUPA'S COMMENT ABOUT San Miguel Arcángel was brief and to the point: "It is a real mission." His focus in this painting is the cloister garden and a beautiful, though modern, fountain that actually sits on the other side of the cloister (outside the walls rather than inside the cloister quadrangle). When he was questioned about changing the fountain's location in the painting, he simply replied, "It needed a fountain there." The foreground of the painting is devoted to the fountain and the encircling red tile walk that embraces the fountain and then leads the eye directly into the cloister in the background. Generous, wide archways lead into the covered cloister walk. Tupa seems fascinated by the light and colors in the fountain's play of water. The artist's style in this particular part of the painting is

An angel stood by the altar of the temple.

Having in his hand a censer of gold.

While John was looking at this sacred
mystery, the Archangel Michael
sounded a trumpet: Forgive us, O
Lord, our God, You open and loose the
seals of the book of life. (Apoc. 8)

Bless the Lord, all you God's angels:
you that are mighty in strength,
and that do God's will.

Bless the Lord oh my soul and all that is
within me, praise God's holy name.

Holy archangel Michael, defend us in
battle: that we may always find peace
in the message of God.

71

different from the surrounding areas; paint is layered and dripped. The water becomes a living organism in the quiet cloistered surroundings.

DESERT, CHURCH AND BUILDING
12 3/4 x 18 inches
Watercolor/pen and ink
on paper, 1997.

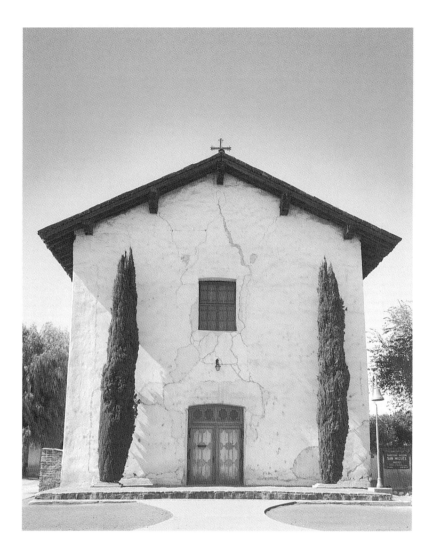

The sixteenth mission, San Miguel Arcángel, was founded July 25, 1797, by Father Fermín Lasuén. The modern fountain in the outer courtyard is a concrete replica of the fountain at Santa Bárbara. The mission is named for the Archangel Michael, the warrior angel and symbol of Church militants. The Mission San Miguel Arcángel is an active church and monastery in the town of San Miguel, a small community midway between Los Angeles and San Francisco.

SAN MIGUEL ARCÁNGEL

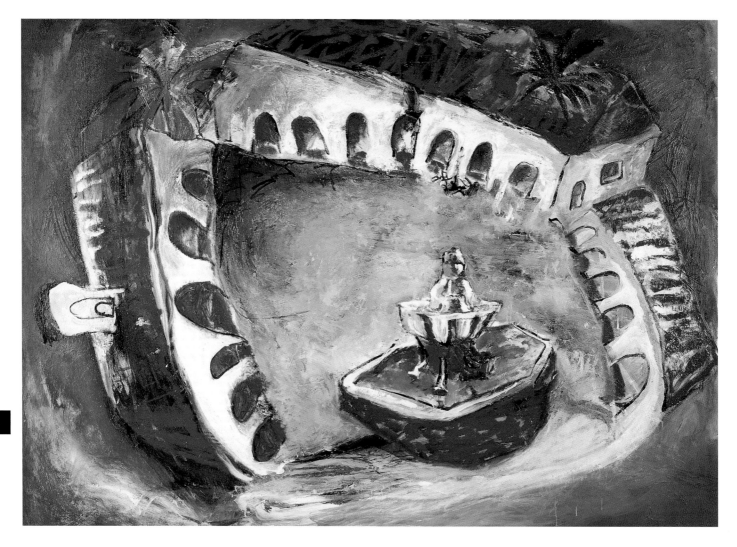

AN UNCOMMON MISSION

CLOISTER GARDEN AND FOUNTAIN

62 x 86 inches

Oil on canvas, 1997

CLOISTER GARDEN AND FOUNTAIN is one of the early paintings in the series and, as such, bears hallmarks that link this series to Tupa's earlier work—sweeping brushstrokes and a highly textured surface built up in layers. In this painting, color rather than outline defines space. The outlines, which occur sporadically throughout the painting, seem to confine color when it threatens to overwhelm the structure of the painting. Tupa's work often contains multiple viewpoints, as it does in this painting where the viewer sees the fountain from a more-or-less normal perspective. But the buildings, diminished in size with respect to the fountain, are seen from almost a bird's-eye view. This technique lends a completeness to the mission paintings; the viewer is provided with a view of the whole mission—not an illustration—a concept of the mission in its entirety.

75

All Provident Lord: grant that all peoples,
rich and poor, high and low,
may search for justice, freedom, and joy
so that our world may be a place of
peace where all can find a home.

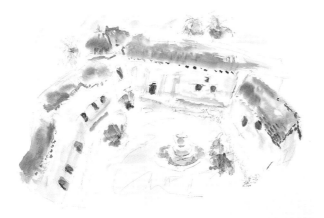

CLOISTER, FOUNTAIN
AND BELL TOWER
29 ½ x 41 ½ inches
Watercolor/pen and ink
on paper, 1997.

The blue surrounding the buildings, one feels, is both sky and not sky, a gentle, textured, moving blue that encloses the mission on all sides.

Outside of the great blue circle, the edges of the canvas hint at an outer sphere of warmer red enclosing the whole. The cloister garden is painted in layers of green, yellow, and occasionally blue paint with touches of orange. The overall pale green cast of the cloister garden changes to deep blue at the upper left. The cloisters at the left and right are linked to one another in a great circle by a wide swath of white paint that begins as an element defining arches at the right. The white strokes move downward to mix and join with the blues of the outer circle and the yellow green of the cloister garden to form a nearly complete circle with the cloister on the left.

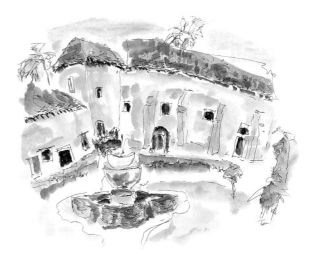

CLOISTER WITH FOUNTAIN
AND THREE PALMS
12 ¾ x 18 inches
Watercolor/pen and ink
on paper, 1997.

76

This painting bears a close relationship to one of the watercolors Tupa completed at the mission (*Cloister, Fountain and Bell Tower*) in which all the elements are present that appear in the oil painting. In the oil, however, Tupa transforms the scene, pulling the fountain out of the cloister garden and using it as an anchor for the composition.

Father Fermín Lasuén founded mission number seventeen on September 8, 1797, and named it for Saint Ferdinand (1199–1252). Ferdinand III of Castille had been King of Spain (1217–1252). During his reign, most of Andulasia was recovered from the Moors, thus assuring him a place in the history of Western Christendom.

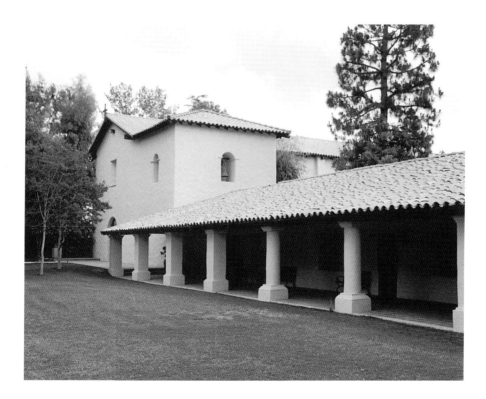

SAN FERNANDO REY DE ESPAÑA

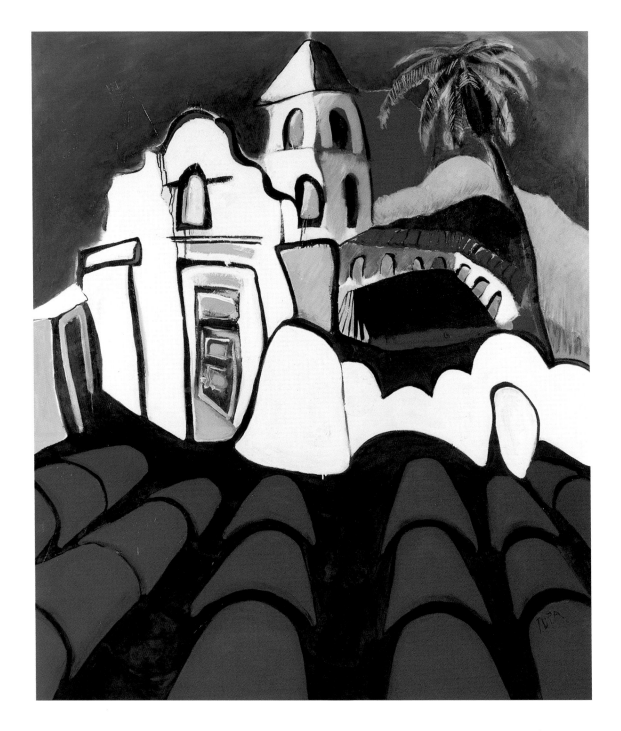

An Uncommon Mission

VIEW FROM LAUNDRY

71 x 60 inches
Oil on canvas, 1997

VIEW FROM THE LAUNDRY is one of the most powerful images in the series. The beautiful almost abstract shapes that make up the individual components of this work are so compelling that the viewer is tempted time and time again to savor each detail and only reluctantly bring back to focus the composition as a whole. The palette in this painting is exactly the same as that used in the others, yet each color is saturated and intense. Powerful diagonals of red roof tiles, each floating in splendor on an undulating black surface, direct the eye toward the mission. The mission itself is a compilation of organic, amorphous shapes that, like the black area, seem to undulate across the surface of the canvas. Blue sky, golden mountains in the background, and Tupa's ubiquitous palm tree anchor these abstract shapes in a physical reality that is playfully denied by the almost unrecognizable white wall that extends from the mission façade.

O God, You removed blessed Louis,
Your confessor, from an earthly throne
to the glory of Your heavenly realm;
grant, we pray You, through his merits
and prayers, that we may be permit-
ted to walk the roads of this world
making them brighter and more
peaceful for all who we meet.
May this mission of San Luís Rey
inspire all who pass by with the love
that animates all things.
We ask this through Christ our Lord.
Amen.

79

San Luís Rey de Francia is the eighteenth mission, founded June 12, 1798, by Father Fermín Lasuén. It was named for the thirteenth century crusader king, Louis IX of France.

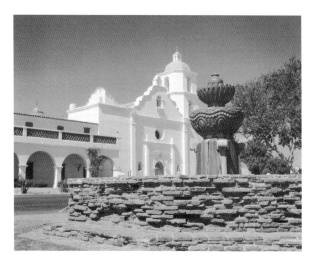

GARDEN WALL/CHURCH/
CLOISTER/PINK DOOR
29 ½ x 41 ¾ inches
Watercolor/pen and ink
on paper, 1997.

WALL, GARDEN,
CHURCH AND CLOISTER
29 ½ x 41 ½ inches
Watercolor/pen and ink
on paper, 1997.

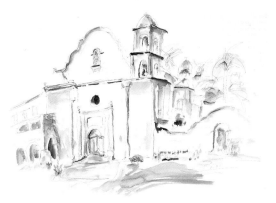

AN UNCOMMON MISSION

CLOISTER, TOWER AND CHURCH: DIPTYCH

46 x 40 inches left, 59 x 48 inches right
Oil on canvas, 1998
(overleaf)

CLOISTER, TOWER & CHURCH: DIPTYCH is a complex painting in which Tupa explores many of the ideas at work in this series. As in the painting of the Mission San Juan Bautista, Tupa plays with a format long established for spiritual painting; the diptych—a painting with two complete and discreet, same-size, stand-alone components that together form an understandable unit. Tupa's compositions are different from medieval diptychs in that his panels differ in size. Most important, however, is that each part is necessary to the understanding of the whole. This painting, which depicts both mission and cloister, is divided through the façade of the mission chapel.

Tupa continues to explore in this painting the idea of giving the viewer interior as well as exterior views of the mission chapel. Tupa uses parallel lines to indicate the dissolution of surface structure, as he did in the paintings of

VALLEY, HILLS AND MISSION
30 x 44 inches
Watercolor/pen and ink
on paper, 1997.

81

When Agnes neared her place of death
she blessed God, for with her was an
angel of the Lord as a guardian.
Ever sheltering God, surround us
with Your protection and keep us free
from anxiety and touch our hearts
with knowledge of Your love.

AN UNCOMMON MISSION

Mission Santa Cruz and the Mission San Buenaventura, with subtle variations here. The colors of interior views are softened by the addition of pastel tint to the already established color scheme (blood red becomes pink, rich golden yellow becomes somewhat paler).

The mission is seen from different viewpoints at one time, and shadows seem to develop an abstract life of their own in this composition. Notice the playful red and blue shadows cast by the arches at the far right, and the pale yellow shadows highlighting the pink floor within the mission chapel. The golden belltower that leans against the mission chapel is given solidity by the use of dark blue shadow, as are the deep arches of the cloister walk. At the juncture of the two paintings, the cloister wall merges with and becomes the floor of the mission church. This painting is only titularly a painting of a California mission, its true subject is the painter's translation of ideas into intense compositional forms.

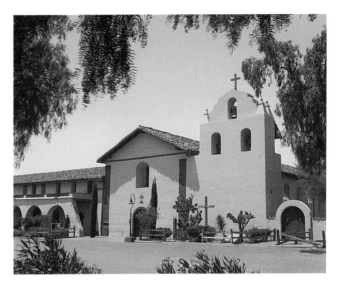

Mission number nineteen, Santa Inés, in Solvang, California, was founded by Father-President Estévan Táis in 1804 and dedicated to the virgin Christian martyr, Saint Agnes. Of all the missions, this was one of the most prosperous and one of the loneliest due to the inland location of the mission in the Santa Ynez Valley. According to the mission history, nowhere in the chain of California missions were visitors more welcome because the isolated mission had so few of them.

SANTA INÉS

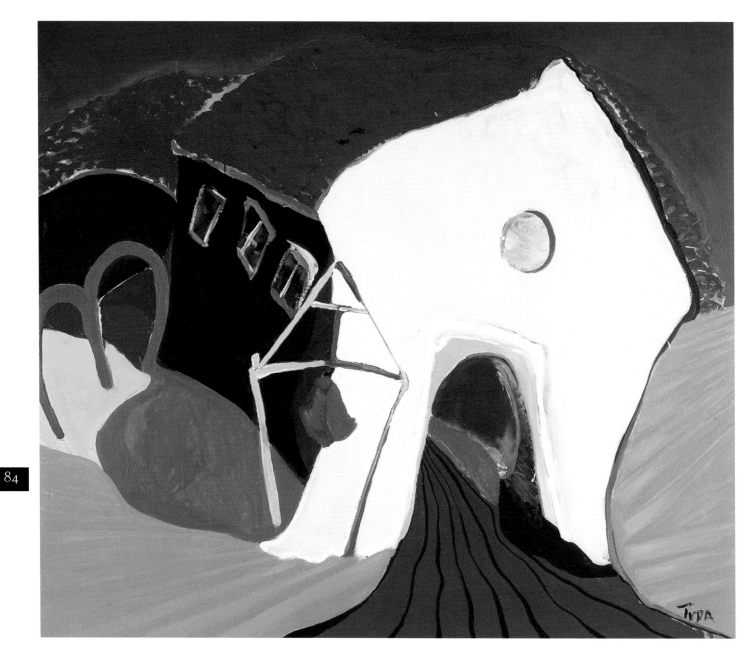

AN UNCOMMON MISSION

A MODEST BELL

40 x 46 inches
Oil on canvas, 1998

TUPA LOOKS AT THE CALIFORNIA mission as a contemporary artist. He is not trying to recreate a historical period or create a true photographically realistic depiction of physical structures. He takes artistic license to deal with his subject matter, a structure and its surroundings, in any way his art compels him to, bound only by his own ideas and imagination. The present-day Mission San Rafael sits in downtown San Rafael, claustrophobically hemmed in by other buildings and roads, and perilously close to the highway. Today it is difficult to imagine this as an outpost in the wilderness.

Tupa's painting of the Mission San Rafael manages to give the little white structure, topped by the ever-familiar red tile roof, a feeling of life and vibrancy that would be photographically impossible. Movement

God of all prophets and hearers
of Your Word,
You sent your angel Rafael as a healer
and fellow traveller for Tobias that
he might not be alone and arrive
safely at his home.
May this angel who stands before Your
face present our prayers for healing
and love so that we may not be alone.

85

surrounds the mission chapel. Into this structure flows a red path, like a river. Green parallel lines fan out to either side of the mission, hinting at verdant fields. Tupa enlivens an otherwise simple composition with playful abstract forms—the diamond-shaped little wooden bell structure in yellow and blue and the bright blue arches that end in a pool of blue next to the mission walls.

VALLEY, HILLS AND MISSION
30 x 44 inches
Watercolor/pen and ink
on paper, 1997.

AN UNCOMMON MISSION

Mission San Rafael Arcángel is the twentieth of the California missions. Father Vicente Francisco de Sarriá founded it on December 14, 1817. Originally this mission was meant to function as a place of rest and recuperation for the Native American populations at the Mission San Francisco de Asís, who were being decimated by unfamiliar diseases. San Rafael offered a warm escape from the damp and fog of San Francisco. The mission was named for the Archangel Raphael, the patron saint of good health. Raphael means "God heals." in Hebrew.

SAN RAFAEL ARCÁNGEL

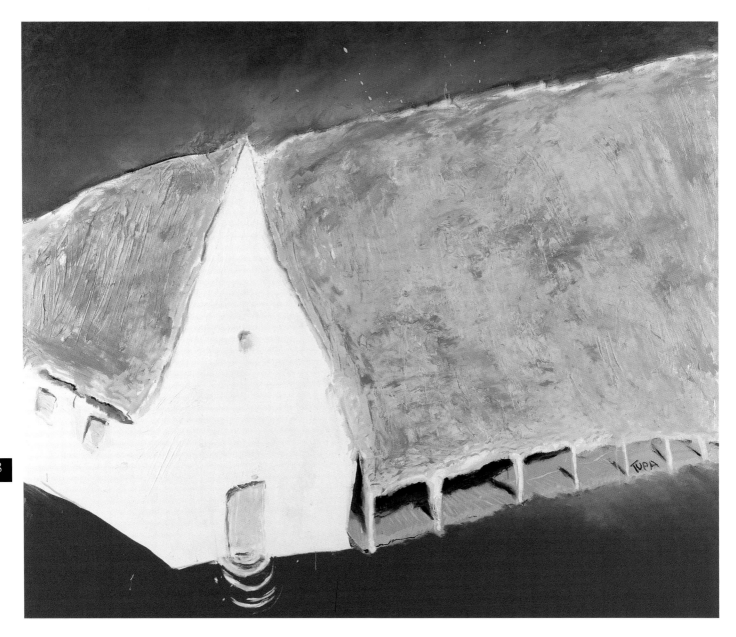

CHURCH AND CLOISTER

60 x 71 inches
Oil on canvas, 1998

ON THE EDGE OF THE LITTLE TOWN of Sonoma in Northern California is the Mission San Francisco Solano. The present-day restored version of the 1840s parish church that sat on this site is a quiet note in an otherwise lively little town. Tupa recalls that it was blisteringly hot on the day he visited San Francisco Solano, and in his painting of the mission he draws on that experience. The focus of the painting is the proverbial red tile roof that is turned a brilliant, gleaming, textured gold by the sun. The overall impression is of heat that blurs and changes the way things are perceived. The golden roof crowns the tiny chapel structure and overwhelms the simple overhang that extends from the side of the mission. No patch of green relieves the composition. The area surrounding the mission is a brilliant red

89

God the merciful and holy let Your Spirit
descend on us who search for You in
pilgrimage to Your holy mission
of Saint Francis.
Be with us every step of the way so that
our going and coming may be a
movement of peace and joy.

THREE PILLARS/THREE
WINDOWS/MISSION ROOF
14 x 18 inches
Color wash/pen and ink
on paper, 1997.

unrelieved except for yellow arcs radiating from the chapel entrance. The sky is a solid patch of bluish-green pushing the yellow-gold roof to full intensity.

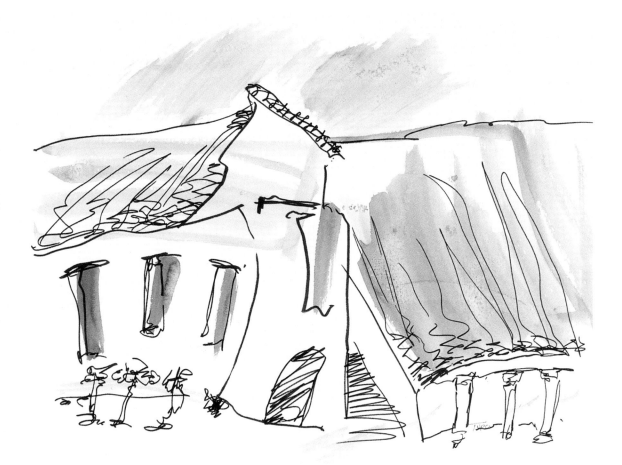

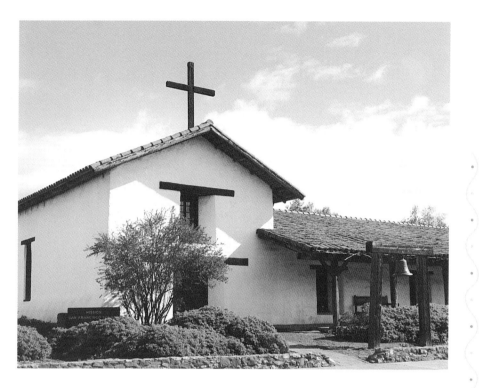

The last of the California missions, San Francisco Solano is mission number twenty-one. It was founded on July 4, 1823, by Father José Altimira, though he did so without proper authority. The mission was officially recognized by Catholic Church authorities in 1824. The mission is named for the sixteenth-century Andalusian missionary, Saint Francis Solano, known best for his work among native peoples in Peru.

SAN FRANCISCO SOLANO

ABOUT THE ARTIST

Jerome Tupa was born in Rolette, North Dakota, on September 24, 1941. He grew up in various towns in North Dakota and graduated from high school in Cavalier. In 1959, Tupa entered the University of North Dakota and his life changed when he enrolled in an art appreciation course taught by Professor Douglas Kinsey. Tupa has vivid memories of a class visit to Kinsey's studio, telling his biographer, Laurel Reuter: "He created before our very eyes a wonderful bull image that breathed through expressionist line and color. I hungered for a similar creative freedom."

Tupa left the university in 1960 and enrolled in St. Edward's University in Austin, Texas. A year later, he was back in North Dakota, this time in Mayville, at the Mayville State Teachers College.

In 1963, Tupa's life changed irrevocably when he took his vows as a monk in the Order of Saint Benedict at St. John's Abbey, in Collegeville, Minnesota. Five years later, he graduated from St. John's University with a B.A. in French and a minor in art.

Because he was a member of the Benedictine Order, Tupa did not become a painter immediately. At the time of his

graduation, the Order did not need a painter, but did need a professor of French. Tupa moved to Paris in 1969 and over the next seven years earned his License, Maitrise, and Doctorat (Ph.D.) in French at the Sorbonne.

During this time, three important events occurred: Tupa became a professor in Modern and Classical Languages at St. John's University (a position he still holds); while living in Chartres, France, he wrote his dissertation; and he resumed his drawing and painting. In 1974, these early works were publicly exhibited for the first time at the Librarie St. Severin in Paris.

In 1976, Tupa returned from France to take his place at St. John's University. He was put in charge of the French studies program sponsored by the University and located in Aix-en-Provence, the spectacular region that so influenced the painter Paul Cezanne. Over the next several years, Tupa obtained a Master of Divinity Degree from St. John's, and was ordained a priest in 1982. Since that time, Father Tupa has painted and produced an immense body of work, collections of which have been displayed regionally, nationally, and internationally. In 1996, the North Dakota Museum of Art in Grand Forks organized an exhibition featuring Tupa's work. This exhibition, entitled *In Quest of the Spirit*, surveyed Tupa's continuing quest to paint religious paintings in a century that insisted on separating art and organized religion.

93

About His Art

Like many artists, Jerome Tupa visually explores the world around him. A man of ideas and convictions, he is unwilling to compromise his art. He paints what he feels he must in the manner he feels is right. For twenty-five years, he has explored both abstract and representational art. Medium and message are thoughtfully intertwined in his painting. Tupa is a series painter, exploring ideas in sequence until he is finished with one avenue or feels compelled to move on to something new.

As a painter of religious works, Tupa feels himself curiously isolated from other twentieth-century painters. Although spiritual elements are found in contemporary art, Tupa's paintings and his associations with organized religion are considered "suspect" in fine art circles. The 1960s and 1970s saw Western European and North American churches, Catholic and Protestant alike, replacing traditional representational religious paintings with sterilized symbols. Tupa reached his maturity as an artist at a time when spiritual painting—particularly if it was in any way representational—was simply not considered fine art.

Nevertheless, Tupa continued to paint and explore ideas. In 1987–1988 he spent a sabbatical year in Rome. In 1988, the Holy See sponsored an exhibition of his representational paintings about relationships, a series entitled Feu d'artifice. Tupa describes the work in this exhibition: "The series was about the dance and through it I discovered parallels between a couple dancing and the workings of the larger world. I came to believe that the world is engaged in a dance, and to understand the

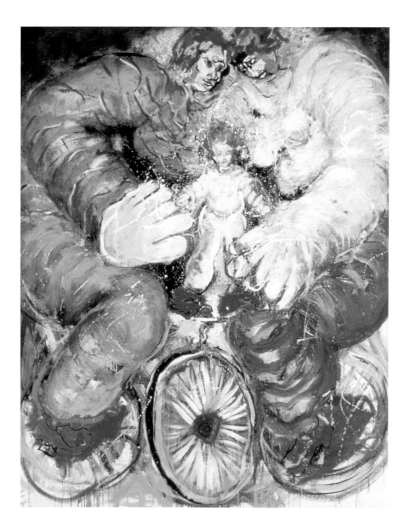

FEU D'ARTIFICE: HOLY
FAMILY: THE HIDDEN YEARS
75 x 60 inches
Oil and gold leaf
on canvas, 1987.

world, we need to understand the relation-
ships of people dancing."

When he returned to the United States
in the late 1980s, Tupa turned away from
representational art to a gesture-based,
abstract style and created a series entitled

Sentinels of Fire. These paintings were
created on a grand scale using large
canvases. The piece from which the series
takes its name, Sentinel of Fire, was painted
in 1988 and is full of movement, texture,
and gesture. A huge, richly glowing orb of

ABOUT THE ARTIST

pulsating color seems to rest on an amorphous, organic shape. Tupa had long been interested in the iconic power of shapes and images found throughout history and prehistory. Of these symbols, perhaps no form is more ubiquitous than the circle—representing variously the sun, eternity, life, and the womb. In the *Sentinels of Fire* series, Tupa explored abstract shapes and the ability of shape and large color fields to soothe and heal the spirit.

Series after series of Tupa's paintings have followed these early explorations. *The Goddess* series is filled with women, both ecstatic, and battered and bleeding. Tupa explains: "I saw them as vulnerable, in need of the healing power I had strived for in the *Sentinels of Fire* paintings. I envisioned this series as a theological statement about our human condition as raw and bleeding and thus dependent upon God's healing grace."

Tupa's *Memorare* series included over sixty small oil pastels on paper exploring holy symbols and writings. Each series represents an in-depth effort to make the spiritual both visible and relevant.

Tupa continues that effort in his latest series. But *An Uncommon Mission* was just that for Father Tupa. The project allowed him to spend a concentrated amount of time focusing on these iconic structures, so similar in many ways, and yet each posing specific aesthetic concerns and challenges for the contemporary artist. That Father Tupa readily met the challenges is evident in the twenty-one oils and thirty-nine watercolors displayed here.

96